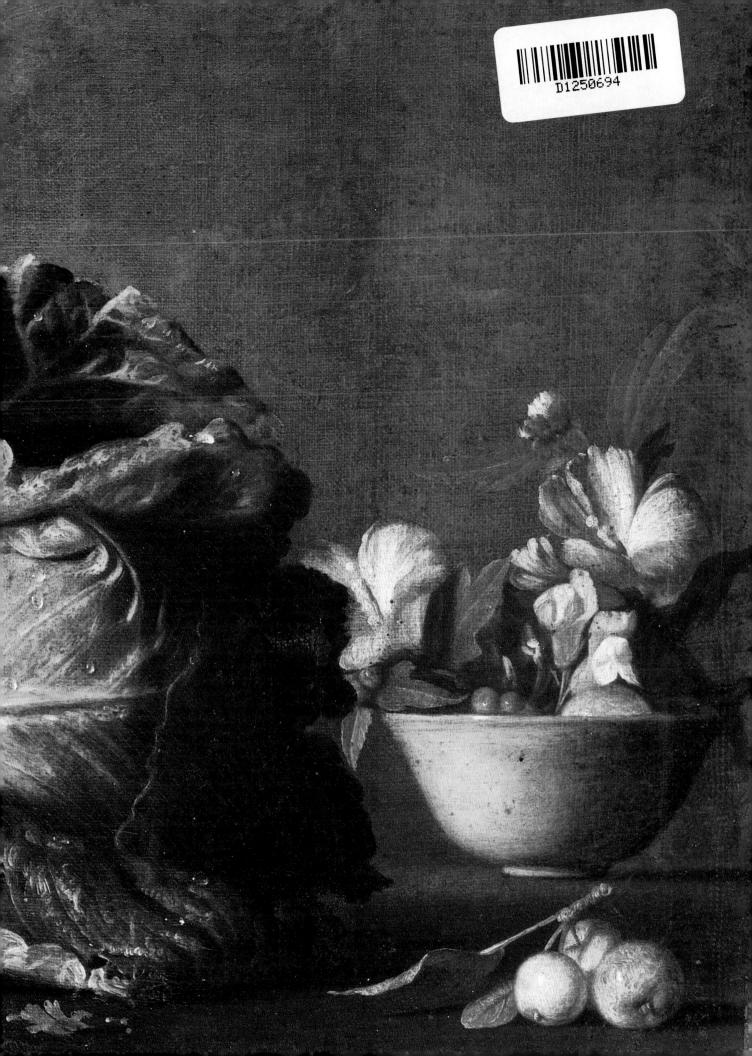

STEP-BY-STEP Art School STILL LIFE

WITHDRAWN

Little Elm Community Library 500 Lobo Lane Little Elm, Texas 75068

STEP-BY-STEP Art School STILL LIFE

JACK BUCHAN AND JONATHAN BAKER

CHARTWELL BOOKS, INC.

For copyright reasons this edition is for sale only within the USA

This edition published in 1993 by Chartwell Books, Inc. A division of Book Sales, Inc. 110 Enterprise Avenue Secaucus, New Jersey 07094

First published in Great Britain in 1993 by Hamlyn an imprint of Reed Illustrated Books Limited Michelin House, 81 Fulham Road, London SW3 6RB and Auckland, Melbourne, Singapore and Toronto

Copyright © 1993 Reed Illustrated Books Limited

ISBN 1555218296

All rights reserved. No part of this publication may be reproduced, stored in a retrieval system, or transmitted in any form or by any means, electronic, mechanical, photocopying, recording or otherwise, without the permission of the copyright holders.

Produced, designed and typeset by Blackjacks 30 Windsor Road, London W5 5PD

Separated by Toppan Printing Co (HK) Ltd, Hong Kong Produced by Mandarin Offset Printed and bound in Hong Kong

For Blackjacks:
Artwork and demonstrations for:
Old Telephone, Flotsam & Jetsam, Aubergine Parmigiana,
Make-Up and Toaster – Roy Ellsworth;
Venetian Washing Line, Satchel, Hat & Coat, Daisies on Kilim,
Lobster and Potted Geraniums – Ian Sidaway
Photography by Paul Forrester
Additional photography by Chas Wilder
Edited by Angie Gair

Credits

Front cover main photograph Ian Sidaway; pp2-3 Private Collection/Bridgeman Art Library, London; pp10-11 Musée des Augustins, Toulouse/Giraudon/Bridgeman Art Library, London; p12 top Harold Samuel Collection, Corporation of London/Bridgeman Art Library, London; bottom York City Art Gallery/Bridgeman Art Library, London; bottom left Musée des Augustins, Toulouse/Bridgeman Art Library, London; p13 top National Gallery, London/Bridgeman Art Library, London; centre Johnny van Haeften Gallery, London/Bridgeman Art Library, London; bottom left Prado, Madrid/Bridgeman Art Library, London; p14 top Private Collection/Bridgeman Art Library, London; bottom Pushkin Museum, Moscow/Bridgeman Art Library, London; p15 top Metropolitan Museum of Art, New York/Bridgeman Art Library, London; bottom Christie's, London/Bridgeman Art Library, London; p16 top Wolverhampton Art Gallery, Staffs./Bridgeman Art Library, London, © Andy Warhol Foundation, New York; bottom left Christie's, London/Bridgeman Art Library, London, © DACS 1993; bottom right © Lincoln Seligman; p17 top left Graham Gund Collection, Cambridge, Mass., USA/Bridgeman Art Library, London, © James Valerio; top right Christies, London/Bridgeman Art Library, London, © Tom Wesselman/DACS, London/VAGA, New York 1993; bottom Courtesy of the Lefevre Gallery, London/Bridgeman Art Library, London; pp142-143 Pushkin Museum, Moscow/Bridgeman Art Library, London.

Every effort has been made to contact all copyright holders of illustrations used in this book. If there are any omissions, we apologize in advance.

Contents

Chapter 1	Introduction	10
Chapter 2	Where to Start	18
	Choosing your Subject Composition	20 c 24
Chapter 3	Without Colour	28
	Materials Techniques Old Telephone Venetian Washing Line	30 32 36 42
Chapter 4	Dry Colour	48
	Materials Techniques Satchel, Hat and Coat Flotsam and Jetsam	50 52 56 62
Chapter 5	Watercolour	70
	Materials Techniques Aubergine Parmigiana Daisies on Kilim	72 74 78 84
Chapter 6	Acrylics	90
	Materials Techniques Lobster Make-Up	92 94 98 106
Chapter 7	Oils	114
	Materials Techniques Potted Geraniums Toaster	116 118 122 130
	Index	140

Chapter 1 Introduction

If you look back through the history of art you will soon realize that nearly every form of art took society lierally hundreds of years to accept, normally through sheer ignorance. This is especially true of paintings that depicted everyday subjects taken from the real world. The main reason for this was the power of the Christian church throughout the Middle Ages. The church not only dictated how people should live their lives but also what they should paint. Therefore, the only acceptable form of art was of a religious nature which included a strong content of Christian symbolism.

Consequently still life paintings were considered low in rank and merely boring reproductions

of everyday things which contained no thought or imagination. However, it is for these very reasons that so many artists have turned to painting still lifes, and why the galleries of the world are full of their masterpieces. Instead of channelling all their energy into the imagination, the artist is freed and can concentrate wholly on pure painting values.

A still life provides the perfect model – motionless with a never ending range of shapes, form, textures and colour. That is why it is such an important part of every aspiring or practising artist's repertoire, and often the starting point of an art class. Therefore it is by no means a minor form of art – in truth quite the opposite.

Introduction

HISTORY

It would appear that the very first still-life paintings in the west emerged from Hellenistic Greece. Unfortunately none of these examples have survived but we have learnt of their existence from the descriptions of ancient writers, which have been brought to light through excavations. The earliest surviving still-life paintings were found buried in the ashes of Pompeii. There were also written references to an artist named Piraikos, who painted shop interiors and simple still lifes of food and wine. Another artist, named Zeuxis, made a painting of a bunch of grapes which, according to legend, was so realistic that birds tried to eat the fruit. These paintings were often executed on wooden panels fitted with folding shutters which meant that they could be easily moved from room to room.

During the Middle Ages western art was dominated by the powerful Christian church, which approved only of paintings of a religious nature and frowned upon the depiction of secular and personal subjects.

The still life as we know it today did not emerge again until the 16th century, when Dutch artists such as Pieter Aertsen (1508-1575) and later Joachim Beuckelaer (1530-1573), began to introduce everyday objects and foodstuffs into the foregrounds of their figure paintings. Gradually these objects began to take precedence and the figures became merely backgrounds. It is thought that this influence came originally from Italy, where Jacopo de Barbari (1440-1515)

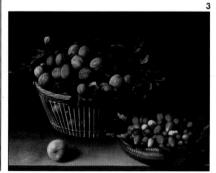

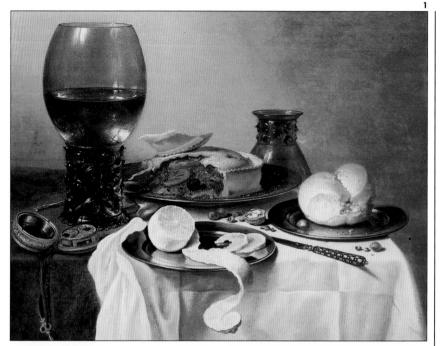

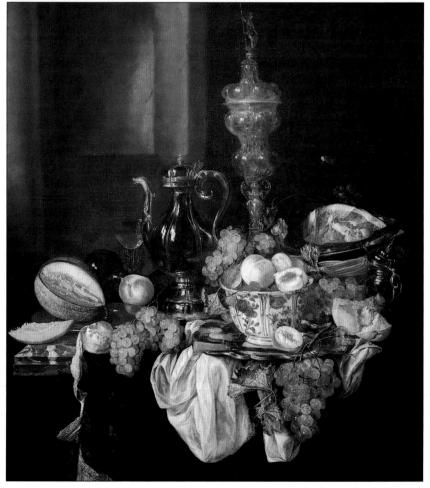

INTRODUCTION

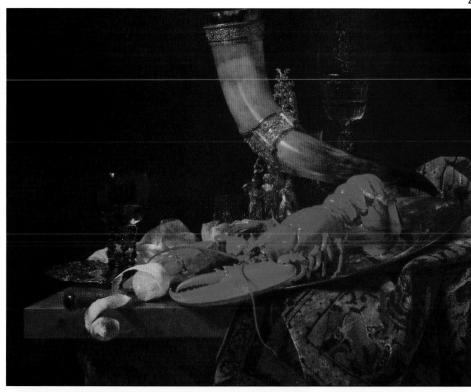

- 1 Breakfast Still Life with Roemer, Meat Pie, Lemon and Bread. Pieter Claesz.
- **2** *Still Life*. Abraham van Beijeren.
- 3 Basket of Plums and Basket of Strawberries. Louise Moillon.
- 4 Still Life. Willem Kalf.
- 5 Still Life of Flowers. Jan Bruegel.
- 6 Still Life. Georg Flegel.
- 7 Still Life. Caravaggio.

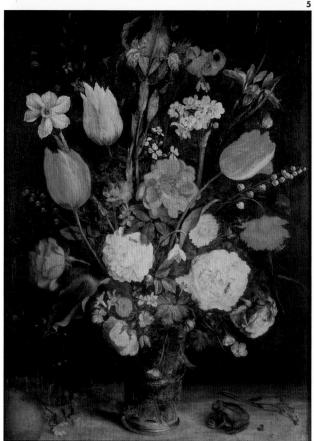

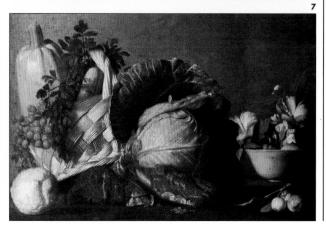

Little Elm Community Library 500 Lobo Lane Little Elm, Texas 75089

HISTORY

had already started to experiment with still-life painting, notably in *Still Life with Partridge*, *Iron Gloves* and *Bolt of a Crossbow*, dated around 1504 and considered to be one of the earliest examples of this genre. Whether this is true or not, it was certainly the Dutch who coined the word *stilleven*, which means 'inanimate object'. In France *nature morte* was the chosen phrase.

One of the most popular themes of the Dutch 17th-century painters was the 'laid table'. Sumptuous scenes of tables set with every type of edible matter such as game, fish, fruit and vegetables, as well as beautiful drinking vessels and ornate bowls were executed to demonstrate the skill of the artist. At the other extreme, simple scenes of bread and fish on a plain wooden table, or bread, water and wine, which had religious associations, were widely painted. Some of the most prolific painters of these scenes in the 17th century were Pieter Claesz (1597-1661), Willem Claesz, Heda (1594-1680) and Georg Flegel (1566-1638) – see pp.12-13, figs 1 and 6. They influenced such artists as Abraham van Beijeren (1620-1690) (see p.12, fig 2), who replaced the simple 'laid tables' with far more lavish compositions, and Willem Kalf

(1619-1693) who incorporated precious bowls and exotically patterned carpets (see p.13, fig 4). Jan Davidsz de Heem (1606-1654) was also an important force who obviously influenced van Beijeren, especially with his love of painting lobsters.

Vases of flowers were also a popular subject and one of the most famous of these flower painters was Ian 'Velvet' Bruegel (1568-1628), son of Pieter. 'Velvet' was a nickname given to him because of his love of rich fabrics. Bruegel would paint vast bouquets of flowers (see p.13, fig 5), some containing over a hundred different varieties, and he would travel to Brussels if he could not find what he wanted in his home town of Antwerp, Ambrosus Bosschaert (1573-1621) also loved painting flowers, but he preferred the more cultivated variety and would often combine flowers that blossomed at different times of the year. This meant that in his paintings he created a kind of botanical encyclopedia.

At this time the south Netherlands was still ruled by the Spanish house of Hapsburg, and so the Dutch style of still-life painting had a strong influence on Spanish artists – most notably Diego Rodriguez de Silva y Velázquez (1599-1660) and Francisco Zurbarán (1598-1664). As well as the Dutch we can also attribute a strong Italian influence on the Spanish artists due to the commercial relationship which was being forged between the two countries. Velázquez's paintings nearly always included figures which shows the strong influence of Pieter Aertsen, and his use of dark backgrounds is reminiscent of the Italian painter Caravaggio. Zurbarán was a friend of Velázquez but his paintings are far more simple and true to life, as are those of Juan de Sánchez-Cotán (1561-1627). In 1603 Sánchez-Cotán joined the Carthusian monastery El Paular as a lay brother;

- 1 · Still Life with a Melon. Pierre Auguste Renoir.
- 2 Still Life with Peaches and Pears. Paul Cézanne.
- 3 Sunflowers. Vincent van Gogh.
- 4 Flowers in a Crystal Vase. Edouard Manet.

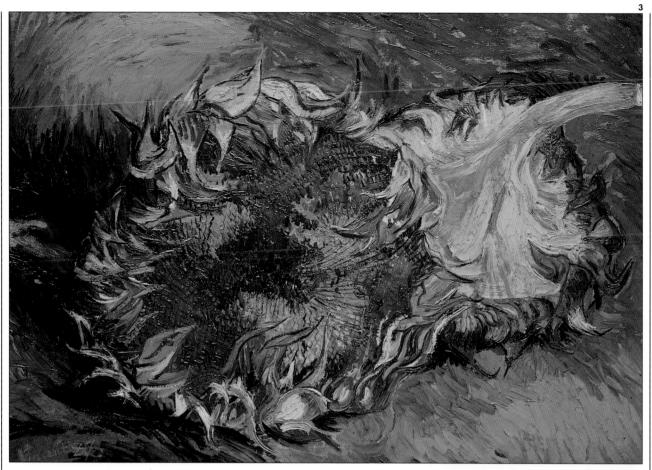

prior to this date – although he still continued to paint – he had produced some of the most notable still lifes of the time, often choosing simple foods in humble surroundings.

Although great artists such as Vincenzo Campi (1536-1591) included still lifes in their figure work, it is without a doubt that Michelangelo Merisi da Caravaggio (1571-1591) was the single greatest influence upon stilllife painters. His real name was Michelangelo Merisi but he was born in Caravaggio and whilst serving his apprenticeship to a local painter people started to refer to him as Michelangelo from Caravaggio. When he arrived in Rome to study further, this was simply shortened to Caravaggio. He was a true painter of naturalism (see p.13, fig 7) and when he painted the simple Fruit Basket in 1596 it was to set a style that would

spread throughout Europe and become a genre in its own right. To quote Caravaggio's own words – "It is just as difficult to paint a good picture of fruit, as it is to paint human figures."

It took France a little longer to accept still-life painting as an important genre but she still produced brilliant artists such as Louise Moillon (1615-1674) (see p.12, fig 3), who loved to paint fruit and flowers, and Jean-Baptiste Siméon Chardin (1699-1779), definitely the most famous painter of still life. He turned away from overly ornate subjects and concentrated his genius on the simplicity of the real world. He had a very refined style and has certainly inspired still-life painters up until the present day.

Our very brief summary of the history of still life concentrates mainly upon the influences of the early

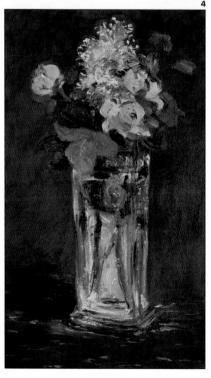

HISTORY

painters who established this form of painting as an accepted art form in its own right. However, it would be impossible to conclude without mentioning the French Impressionists. Although they were mainly concerned with light and the landscape, interiors and everyday objects were also important subjects and Edouard Manet (1832-1883), Camille Pissarro (1831-1903) and Pierre Auguste Renoir (1841-1919) all painted still lifes (see pp.14, fig 1 and fig 4).

Often associated with the Impressionists but not actually members of the group, two of the greatest still-life painters of the 19th century were Vincent van Gogh (1853-1890) and Paul Cézanne (1839-1906). Van Gogh's style was simple and dignified, reminiscent of 17th-century Dutch realism (see p.15, fig 3). He produced some superb examples of still-life paintings which, unhappily, were not recognized as such in his own time. Cézanne on the other hand had a more intellectual approach. He

would spend days arranging his group of objects and, in his own words, "deal with nature by means of the cylinder, the sphere and the cone".

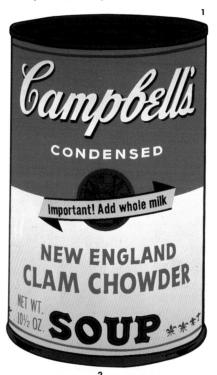

Yet amazingly his finished paintings still have a fresh and spontaneous feel to them (see p.14, fig 2).

It was Cézanne who planted the seeds of a new form of art called Cubism which emerged in the early 20th century. The two most famous artists of this movement were Pablo Picasso (1881-1973) and Georges Braque (1882-1963). Instead of depicting objects from a fixed viewpoint, they set out to represent objects in their entirety – not partially obscured as they would be if conventional perspective were retained. The Cubists were not concerned with what the artist sees, but with what he knows.

Since the Cubists there have been all manner of schools of painting, from Dadaism and Surrealism to Op Art, Pop Art and photorealism. They have all translated the still life in their own way, right up to the present day. This goes to prove that still-life painting is, and without doubt always will be, an important form of art.

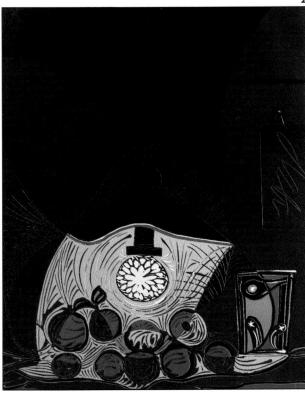

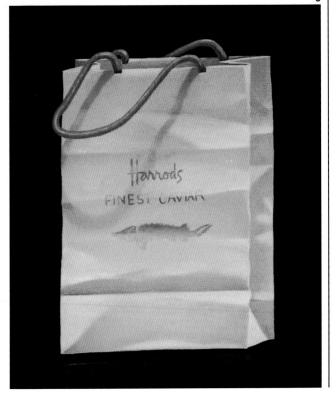

INTRODUCTION

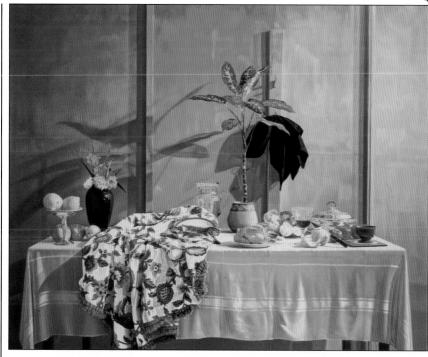

- 1 Campbell's Soup. Andy Warhol.
- 2 Still Life under a Lamp. Pablo Picasso.
- 3 Harrods Caviar Bag. Lincoln Seligman.
- 4 Still Life No2. James Valerio.
- 5 Still Life. Tom Wesselmann.
- 6 Pears. Edward Burra.

Chapter 2 Where to Start

There are two fundamental stages that you must consider before you sit down to draw or paint a still life: choosing the objects and composing the group. With the step-by-step projects in this book both of these steps have already been done for you, since their real aim is to show you how to approach different subjects and use the various media. However, once you are 'on your own' things will not be quite so straightforward.

The content of your works will of course be largely down to your own preferences. But by getting to know the range of subjects which you can depict, and the ways in which objects work together, you will be able to identify what exactly appeals to you in a still life and the reasons why.

Composition is something the experienced artist handles almost without thinking, but even the most seemingly abstract painting normally reveals itself to have an underlying structure. For the less experienced artist and the absolute beginner it is important to understand the elements which go into making a good composition, since however well you can paint or draw, if your pictures are badly composed they will not succeed.

Drawing and painting should always be fun, so we have tried not to labour the 'rules' of composition too strongly. Read through this chapter and study its contents, but remember that at the end of the day your own preferences should be allowed to largely dictate how you work.

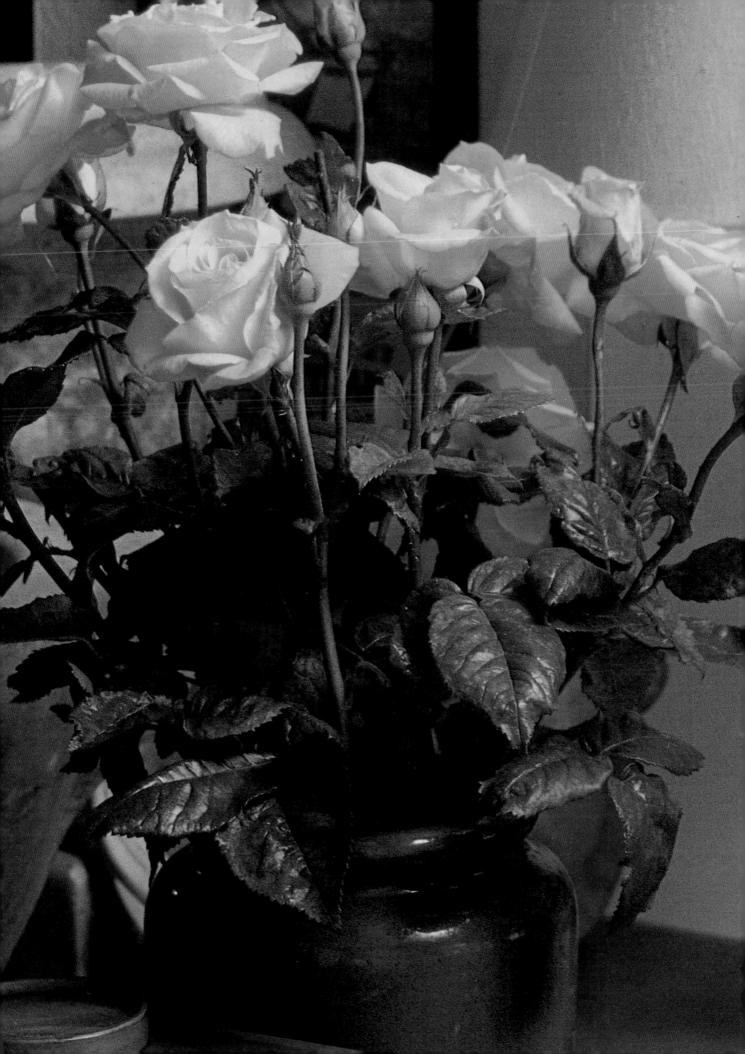

Where to Start

CHOOSING YOUR SUBJECT

The first stage of any still life study is selecting your subject and choosing a suitable medium in which to depict it. Almost any object or group of objects can make a suitable subject for a still-life painting – and you, the artist, have full control over how you interpret your subject. Basically, still lifes fall into three main categories: the 'artificial', the 'found' and the 'natural'.

An 'artificial' still life is entirely created by the artist. He or she selects the objects, arranges them and creates a setting for them, before proceeding on to the drawing or painting itself. Common themes for artificial still lifes include displays of foodstuffs sprawled across a table, neatly arranged flowers and the everpopular bowl of fruit, usually with a piece of artfully draped material as a background.

The 'found' still life, as the name suggests, consists of a subject which just happens to catch the artist's eye – something which has not been deliberately set up, but has a certain uncontrived charm about it. Good examples of this would be objects left on a dining table after a meal, garden implements standing in a tool shed or even a pair of shoes lying on the floor. Of course, you can deliberately arrange a still life to look like a 'found' group, though you must be careful not to destroy the effect by overarranging the objects. All the photographs in this chapter are of 'found' still lifes, but they could just as easily have been deliberately created by an artist, which would have made them 'artificial'.

A 'natural' still life is, as its name implies, a selection of objects (or a single object) found outdoors which have been arranged, not by human hands but by the actions of nature, be it wind, sea or whatever. The objects can be man-made – as in the step-by-step project on page 62 – or natural items such as stones or pieces of old wood. This type of subject is often not

viewed as a still life since it is so far removed from the carefully arranged group of man-made objects which everybody has come to expect.

Obviously the distinction between the three classifications is not always as clear-cut as explained above. Often an artificial still life evolves from a found group of objects, with the artist altering the placements slightly to make a better composition. Even a natural still life can be tampered with which again, in theory, turns it into an artificial group. In reality it is difficult for any still life

not to have an artificial aspect to it because there are so many elements which can come under the artist's control. The lighting, the background, even the colours and tones can be altered in the interest of making a better picture. The real distinction in the categories is not in the finished painting but in its origins.

With a found or natural still life the scene is already set, so you either decide to paint it or not. However, with an artificial still life you take complete control over every aspect – composition, lighting and so on. The You can walk into any room of your house and find a still life waiting to be painted. The bathroom is a particularly rich source for surface textures.

sense of 'creation' that this induces probably explains why this is by far the most popular form of still life. Caravaggio wanted to show that he could take any object and make a beautiful painting which was without meaning; the Dutch painters of the 17th century used it to show their great artistic skills; and the 20th century Cubists analyzed the concepts of shape, form and volume largely through the use of simple still lifes. All these examples readily illustrate the depth of intent and meaning which can only be put into something which is totally the artist's creation.

For the beginner, probably the best forms of still life to try out first are the 'found'. Although most of the still lifes in this book were artificially created by the artist, for you the reader they become 'found', since they are already set up ready for you to paint. Once you get used to painting, and start to know what type of still lifes you prefer, you can begin to work towards creating your own arrangements.

Themes

As you can see from the assortment of photographs in this chapter, and from the step-by-step projects themselves, almost any object can be used in a still life. This attitude of 'anything will do' is particularly well summed up by a quote from the French Impressionist, Renoir; "Subjects? I can manage with one or two odds and ends of anything!" Having said that, however, groups of objects do tend to work better together if there is an affinity between them. A typewriter on a desk makes a suitable subject, but place the typewriter in the middle of an assortment of foodstuffs and you end

up with a very peculiar scene. The latter still life may be perfectly composed and beautifully painted, but because the objects do not gel, the effect is spoilt. Always try to devise a 'theme' for your still life, whether it be a culinary one containing kitchen utensils and vegetables, a floral one, or a 'literary' one containing books, pens and so on.

Choosing a Medium

Although any medium can be used to depict any subject, often you will find that you instinctively choose a 'best match'. If you want to work in a particular medium then try to pick a subject which suits it and vice versa; as a very basic example, a monochrome rendering in pencil, ink or charcoal is obviously more suitable for a monochromatic subject (as illustrated by the two projects in the *Without Colour* chapter) whereas a still life which contains lots of bright colours (like the gouache project on page 84) would be wasted with such a rendering. There are no hard-and-fast rules to follow, but instinct and common sense should be applied.

COMPOSITION

Even with a found still life, you may find it necessary to alter some elements slightly in order to improve the composition. But once you are into the realms of artificial arrangements, composition becomes one of the most important considerations. The ancient Greek philosopher Plato said that "composition is the skill of finding and representing unity within diversity", which sums up the basic rule for any composition. In other words, to be pleasing a picture should contain enough vitality to hold the viewer's interest. But that vitality must be organized and kept in check, otherwise the picture becomes meaningless. If you concentrate too much on the unity of a scene, it ends up looking monotonous and uninteresting; introduce too much diversity and the objects become scattered, each attracting individual attention and so destroying the harmony of the group. The skill is in

touching the right note between anarchy and monotony.

There are many elements which effect the composition of a still life, but perhaps the most important – in no order of merit – are colour, lighting, symmetry (or asymmetry), texture, viewpoint and design.

Colour

Convention would imply that all the colours in a still life should be harmonious. So, for example, you might choose a range of 'warm' colours – reds, yellow and oranges – or a range of 'cool' colours – green, blues and greys. This approach can be further refined by the use of a limited palette of colours and by ensuring that all the colours present contain traces of each other. This results in a painting which has a great sense of harmony and unity, even when this is not present in the actual objects themselves.

However, what you must remember is that no convention in art is totally rigid. For instance, if you wanted to create a still life with a great sense of vitality, you could do this by having variety in the colours. A more subtle approach could involve using an overall warm colour scheme, but including one or two spots of cool colour to provide the 'punch'.

One way to stress a particular area in a painting is through the use of complementary colours. The complementaries are red to green, yellow to violet and orange to blue. When placed side by side the complementaries accentuate each other, and this can be used to great effect in a painting. For example, if you have a still life which contains a lot of green hues, then a red element placed within it will stand out dramatically. The oil painting project on page 122 is a good example of the use of the red/green complementaries.

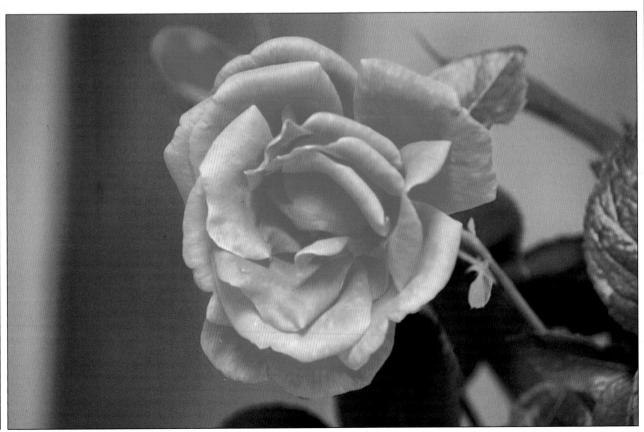

WHERE TO START

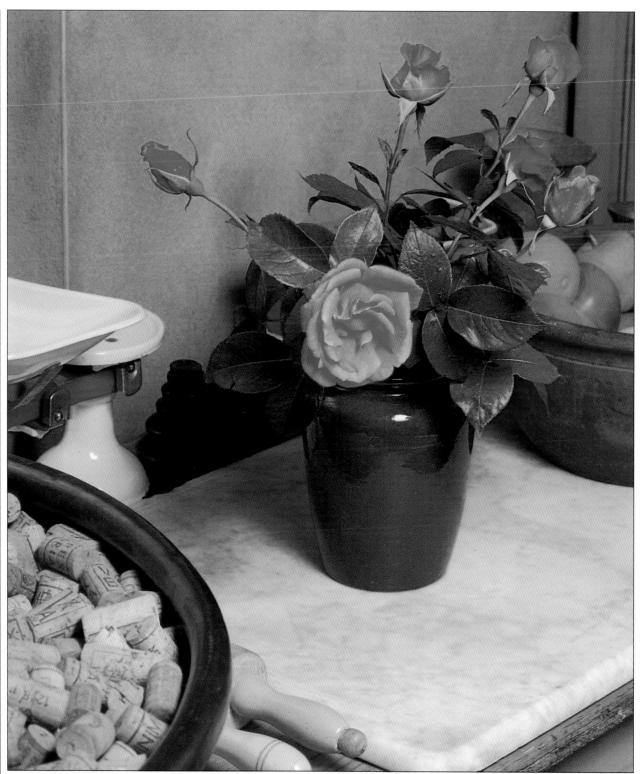

Some roses in a jar provide two remarkably different still life projects – one in extreme close-up, the other at a distance.

However, both readily lend themselves to being painted with particular regard to the use of complementary colours. The contrast of red on green is vivid enough in real life.
Accentuate the colours, even by a modest amount, and you

end up with a picture that would leap out at the viewer, demanding their utmost attention.

COMPOSITION

Lighting

When creating an 'artificial' still life you not only choose and arrange your subject, you also take complete control of the lighting. Even when working with found and natural still lifes you can, if you wish, adjust the lighting to suit your purposes. With a natural still life the weather will change the light without your intervention, but you can choose a particular time of day – harsh lighting at mid-day right through to the softest light at twilight – and your viewpoint will also alter the way the subject is lit.

Lighting is a very important aspect of still-life painting. The quality, direction and type of the light will affect the colours and tones of the objects, the sense of form and space, and the mood of the finished painting.

'Quality' describes whether the light is diffused or direct. Artificial light produces direct lighting which emphasizes the volume of objects and casts strong shadows. Outdoors, the sun too produces direct light, except on hazy or misty days, when it is more diffused.

The direction of the light has a major influence on the impression of form and the overall mood in a still life. Lighting direct from the front tends to flatten the contrast but stresses the colours, and is often used by artists who want to express form simply through the use of colour. When a still life is lit from the rear with natural light it produces a soft effect which can be used to great effect in a still life, but if artificial light is used the contrast can become very hard – although in some cases this may be something you wish to achieve. Lighting from the side-

> In this photograph daylight is diffused into a basement window. The soft backlight gives the group a gentle appearance, yet the harsh white of the wall adds interest.

especially at a 45 degree angle from yourself – is the most commonly used for still life subjects, since this accentuates the modelling of the tones.

Types of light are basically split into artificial or natural. Artificial light allows you to work at your convenience since, unlike sunlight, it will not change. It is also extremely useful in creating special effects. But it does have one major disadvantage. Tungsten bulbs have an orange cast which distorts the colours you see. With experience you can correct this, but for the beginner it introduces an

unnecessary complication. Natural light shows the authentic colours and has a greater diffusion (when not used directly), providing a better quality.

As already mentioned, lighting is also the most important factor in creating the mood of a still life. The type, direction and quality can all be utilized to create effects ranging from the very delicate and softly lit right through to those with harsh contrasts and strong shadows, creating a feeling of tension. Backlighting is particularly moody and atmospheric. throwing the subject into near-silhouette.

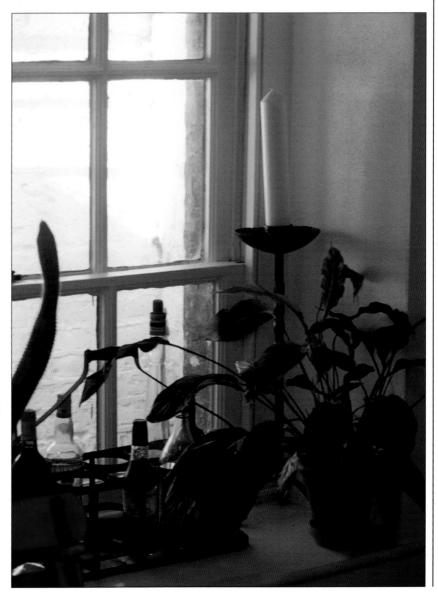

WHERE TO START

Symmetry (& asymmetry)

As explained above, it is normally unwise to have too much unity in a still life. Therefore a symmetrical composition (with both halves of the painting equally balanced) is not exactly 'wrong' but it can result in a rather uninspiring picture. However, symmetrical still lifes have been produced – notably the flower still lifes painted in Holland in the late 16th and early 17th centuries – and

these are successful through the very naïvety of their composition.

Most artists use an asymmetrical composition in their still lifes. Asymmetry refers to a free and intuitive composition in which the shapes, colours and forms are varied, yet each one balances the other – thus achieving unity within diversity. Asymmetrical compositions are synonymous with variety and freedom of expression, and, however

carefully arranged, give an impression of spontaneity.

Texture

Another important element in any still life is the variety of textures present and how they play against each other. It is vary rare for a still life to contain only one texture – even in a still life depicting a bowl of fruit, you have the bowl itself, which provides a second texture, and then there is the surface it is placed upon. A variety of textures – though not too many! - not only makes the still life more fun for you to depict, but also provides interest for the viewer (as is the case with the watercolour project on page 78). By placing contrasting textures next to each other, you emphasize them and give greater vitality to the picture.

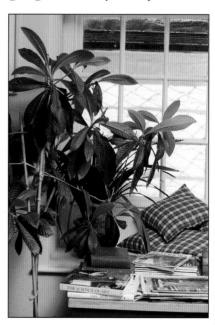

Both these still lifes have a main object placed slightly to one side, making use of asymmetrical compositions. However, the main photograph is still quite structured through its strong vertical lines. This makes it appear much more posed than the plant shot, even though this is not the case.

COMPOSITION

Design

The design of virtually any successful painting can be broken down into one distinctive geometric shape which dominates the composition. It would seem that however complex a scene, if there is an underlying geometric pattern then the viewer unconsciously relates to this and so enjoys the painting more.

During the Renaissance period almost every aspect of a painting was

planned out with mathematical accuracy. The most famous of the compositional formulae used was the proportion called the Golden Section (see diagram A). This is a device for splitting up the picture space in an interesting way and working out the ideal positions for the major elements. Although modern artists rarely follow the golden section consciously, it is interesting to note how so many paintings, when analyzed, do in fact conform to its rules, though by no means rigidly.

There is no need to get too embroiled in the use of geometric shapes and the golden section. But, if a particular composition just does not seem to be working, try stepping back and giving the overall design further consideration. If no geometric underpattern is present, or if the golden section has been flagrantly broken, then this is almost certainly the root of the problem.

Viewpoint

With any still life the major influence over the finished picture is through your choice of viewpoint. When setting up your still-life group it is always a good idea to look at it from several different vantage points before you begin to draw or paint it. For example, you may find that a group which looks uninteresting from a 'normal' viewpoint becomes much more exciting when viewed from one side or from slightly above.

The best viewpoint depends largely on what you want to achieve. For instance, an eye-level viewpoint is not normally used since it tends to flatten the group through lack of

These two photographs illustrate how a shift in your viewpoint can radically alter a still life. This should be one of your main considerations when painting, especially with 'found' and 'natural' still lifes.

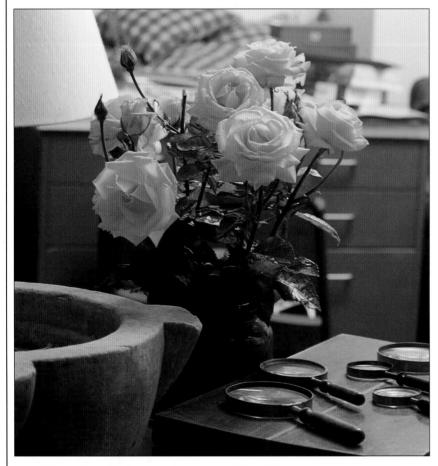

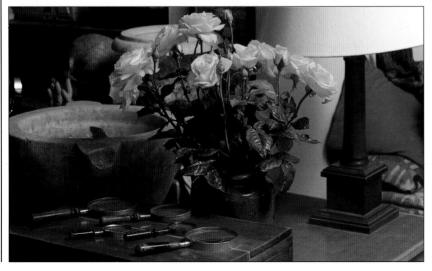

WHERE TO START

perspective, but it is a simple device in creating an unusual painting which will catch the viewer's eye. Other extreme viewpoints also provide eyecatching works and this element of the unexpected gives them an underlying tension not necessarily present in the objects themselves.

Perspective

Though most still lifes are viewed close up, you will still need an understanding of basic perspective in order to draw objects such as bowls, cups, tables and boxes convincingly. Perspective is dependent on your viewpoint. There are two basic types; parallel and oblique, (see diagrams B and C), and both are easy to master once you can identify the horizon line, your centre of vision and the vanishing point. The horizon line is always at eye level and is found by looking straight ahead. Your centre of vision lies on the horizon line in the middle of whatever direction you are looking. The vanishing point is the point on the horizon line at which all parallel lines that recede into the distance appear to converge (imagine standing in the middle of a long road). With a parallel perspective the vanishing point will also be your centre of vision, whereas with an oblique perspective there will be two vanishing points, one on either side of your centre of vision.

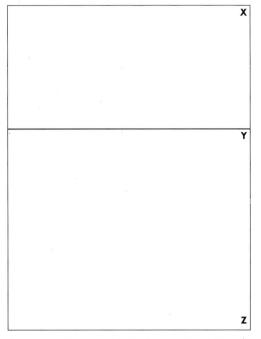

The golden section is the division of a line into two parts so that the ratio of the shorter length to the longer is equal to the ratio of the longer to the whole line. Here the line XZ has been split in this way. The ratio of XY to YZ is the same as the ratio of YZ to XZ. This ratio is roughly 8:13 or more precisely 1:1.61803398 (a calculator is recommended!) and when you draw a line out from point Y vou will have divided the area at its horizontal golden section. A rectangle can be subdivided this way horizontally at the top or bottom, or vertically left or right.

DIAGRAM A

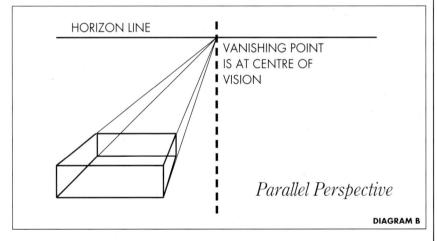

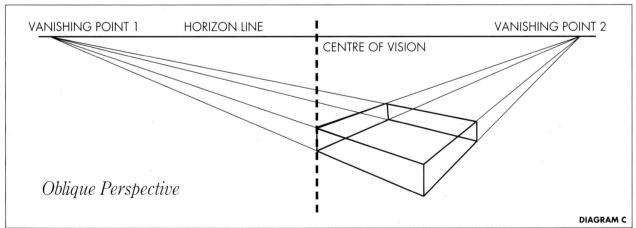

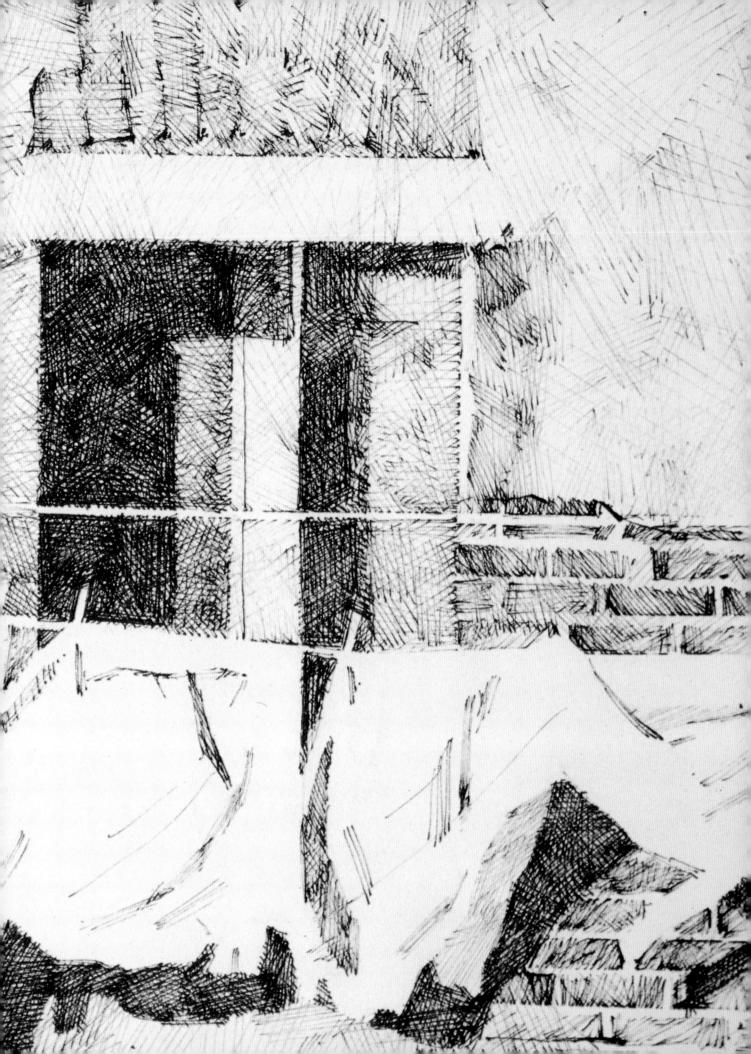

Materials

CHARCOAL AND INK

Charcoal

Charcoal is the oldest drawing medium, dating from prehistoric times. Today, charcoal is made from carbonized vine or willow twigs and is available in natural or compressed sticks, in pencil form, or as a powder. The sticks come in various thicknesses and are capable of creating a range of marks, from fine and detailed to broad and painterly. This range of impressions may be

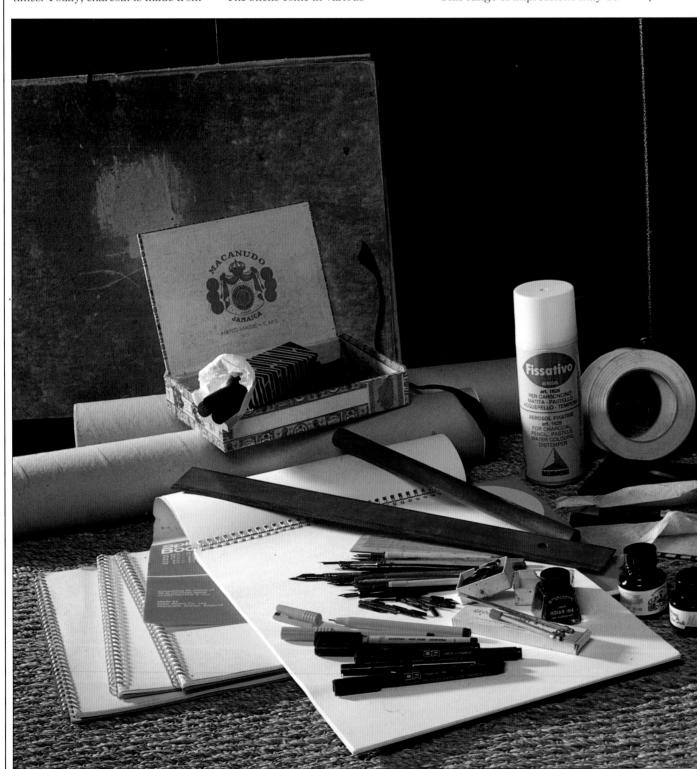

MATERIALS

obtained with one stick, as you can sharpen it to a point or snap off a short length and use the side of the stick for broad tonal effects. Charcoal pencils are cleaner to handle, but only the tip can be used, so they cannot produce side strokes.

Supports

Practically any type of textured paper will provide the perfect surface when working in charcoal. The medium will not adhere well to a smooth or glossy finish and will smudge very easily, and literally fall off! Therefore choose Ingres, Canson or, for everyday practise the cheaper sugar paper.

Other equipment

There is very little in the way of extras that you will need when working with charcoal. However, a fixative spray is essential to bond the loose particles of charcoal to the paper surface and prevent smudging. You can buy fixative from any art shop but a cheaper alternative is ordinary hairspray. You will also need sandpaper and a sharp blade for sharpening, and a kneadable putty eraser to create highlights or correct errors.

Ink

Inks are available in a variety of forms including dip pens, fountain pens, ballpoints, quills, felt-tipped and from bottles using a brush. For the project in this chapter we chose to use a fine liner since it is such an easy introduction to the medium.

Any type of synthetic, fibretipped pen producing very thin, spidery lines can be referred to as a fine liner. These pens are most often used in technical drawing; their fine tips are supported in a metal sleeve which allows close-up use against a ruling edge. They produce very similar results to a technical pen, which delivers a uniform line of precise width, but are basically throw away versions. However, the tip wears and spreads with use and many artists use their older pens for tonal shading (as you will see in the project on p.42). Fine liners work best on a smooth white paper or card as they will bleed on a soft, textured surface.

Techniques

CHARCOAL

The beauty of charcoal is that it is so simple to use and it has a speed and spontaneity which lends itself to expressive drawing. It is the perfect medium for beginners – far better than even graphite pencils – and is nearly always the first medium introduced in art schools because it encourages students to think about the whole subject rather than getting lost in detail. Experiment with lines, varying the pressure to produce different thicknesses. Using the side of the stick gives a broad band which picks up the surface texture of the paper. The tip gives a solid black line with a smooth, flowing quality. For really fine lines, a sharp point can be obtained by lightly rubbing the end of the charcoal on a piece of sandpaper.

Tone

The most useful technique – as well as the most common – when using charcoal is to build up tone with a series of loose strokes (hatching). Draw yourself a small rectangle – which is purely to give yourself a restricted area when practising –and then start to slowly fill it in with loose, gentle strokes starting from one corner and finishing in the opposite corner. For darker tones you can work over from one corner again and again with the same loose strokes. Here it has been done twice to show how different the effect is between using (1) willow charcoal and (2) compressed charcoal, which is produced from charcoal powder pressed with a binding medium.

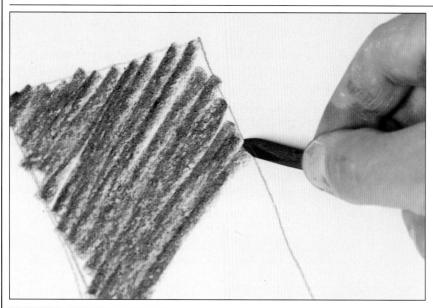

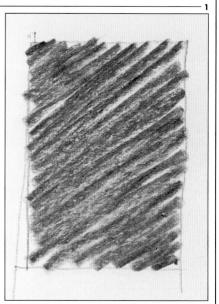

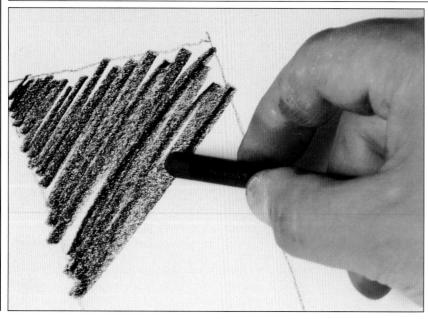

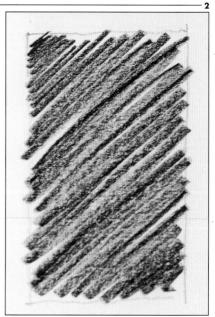

TECHNIQUES

Soft Blending

The fact that charcoal is such a soft medium means that you can blend it with your finger to create a smooth, velvety effect. Again draw a small rectangle and then fill in one side with fairly solid black using the side of the stick for speed. Then, with the tip of your finger, gently rub the charcoal to form a graded tone which has a lovely smooth finish. You can lighten the tone with further blending, or darken it by going over the area again with more charcoal and repeating the process.

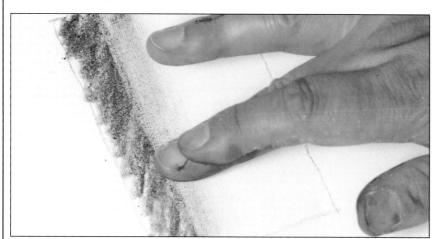

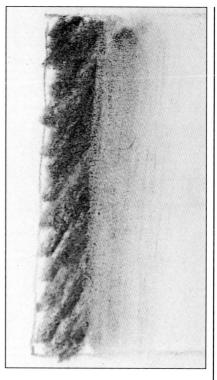

Highlights

To pick out highlights in a toned area you can use either a kneadable putty eraser or a stick of white chalk. Draw a small rectangle with the tip of the stick, and lay a fairly solid area of charcoal. Break off a small piece of the eraser and knead it with your fingers until it is warm enough to mould into any shape. To pick out highlights, pinch the putty to a fine point and use a press-and-lift motion without rubbing. To smudge or subdue the tone, rub

gently with a round ball of putty. The putty can also be pulled across the charcoal – as shown here – to give a band of light through dark (1). When the putty becomes clogged with charcoal, discard it and break off another piece. An alternative to this is to use a stick of white chalk (2) and pull it down the paper in the same way. The real difference with chalk is that the highlights will be much sharper and a purer white.

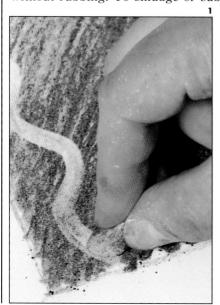

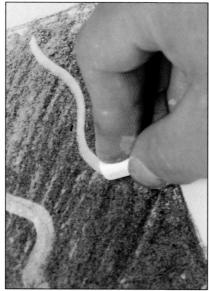

INK

Crosshatching

This is a technique, in which two or more sets of parallel lines are combined, one set crossing the other at an angle. Although originally developed for engraving, this technique can be used with all types of linear media including (1) fine liner felt-tipped pen and (2) a dip pen and ink and some very interesting results can be achieved if you are prepared to experiment. Graduations of tone can be achieved by varying the density of the lines: the more

closely spaced, the darker the tone. The lines can be crosshatched at any angle you like, and even curved. Generally, freely drawn lines look more lively than perfectly straight ones.

In theory an entire drawing can be produced using crosshatching, but it is a labour-intensive technique. More often it is used in small areas of a drawing, its crisp, linear effect providing a textural contrast with the softer lines and shading used elsewhere.

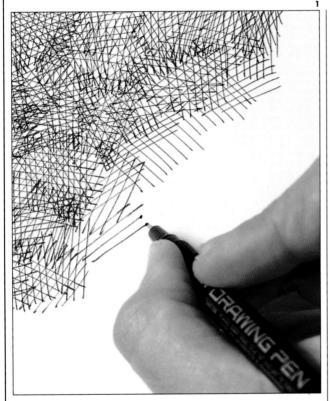

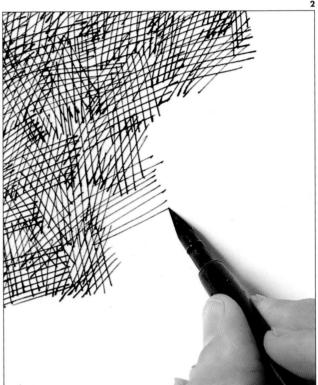

TECHNIQUES

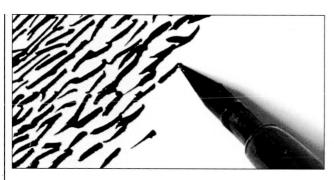

Dashes

When working in monochrome a number of techniques can be used to create tone and texture. Although we have used a dip pen and ink which does not feature in our projects, we have done this because the same techniques apply to a fine liner but they are much clearer to see with a dip pen. Simply lay short dashes of varying lengths in a fairly random way. As you can see from the final picture this technique is ideal for creating textural effects.

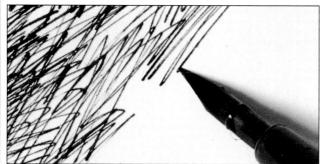

Scribbling

With inks the marks that you can make are fairly restricted, but if you want to create tone or build up dark areas in a very quick and simple way, scribbling is the perfect answer. Using completely random strokes literally start to scribble. This can be in any direction with the lines crossing over each other. In fact this could be described as a loose way of crosshatching.

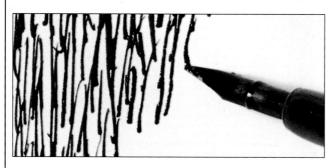

Vertical Lines

This technique is really a variation of the dashes except longer, vertical lines are drawn. Again this is very useful for creating texture and would be ideal for rendering the bark of a tree.

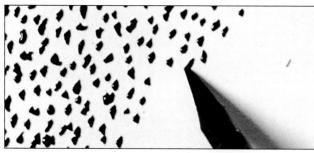

Dots

Here we show how to build tone without using any lines! After all, the photographs in a newspaper are made up entirely of black dots. You create tone by varying the distance between the dots – the closer together you place them, the darker the tone will be.

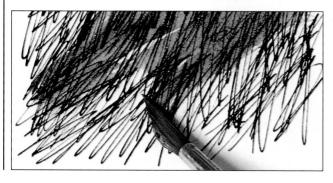

Water into Ink

This chapter is all about working with pens and sticks, but there is one technique which allows you to deviate slightly from the normal lines and dots. Using an ink pen lay an area of scribbles, or any of the previous techniques. Dip a brush into some water and drag it across the area. This will make the ink run and can be used with the minimum of skill to create some very interesting effects.

Old Telephone

CHARCOAL

Although charcoal is considered to be a very loose, quick and easy medium, often associated with simple sketches, it works surprisingly well in rendering more detailed images. The artist loved the classic style of this 1930s bakelite telephone and decided to use it as the basis for this composition. The other objects in the group were carefully selected to be in keeping with the style of the telephone, down to the old-fashioned fountain pen. Even the telephone number jotted down on the pad is an old-fashioned, lettered London exchange. When composing your still life it is always important to pay attention to

small details; in this case a jumbo pen bearing the logo ¹I ♥ New York' would have ruined the credibility of the period feel!

For purely practical reasons the artist used photographs as reference for this drawing. Due to the pressure of time, he decided to take several shots of the group from different viewpoints so that he could choose the best one later on and complete the drawing at his leisure. In the end, his final composition was based on a rough sketch which comprised the best elements from each photograph.

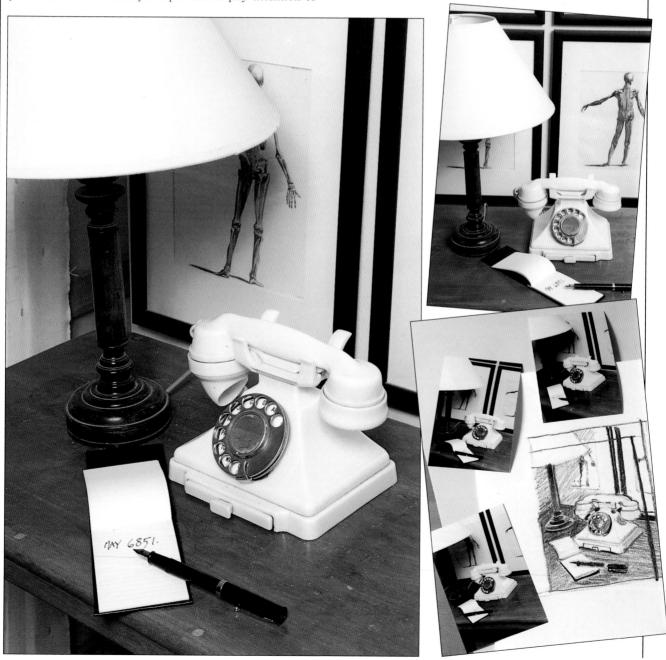

STEP BY STEP

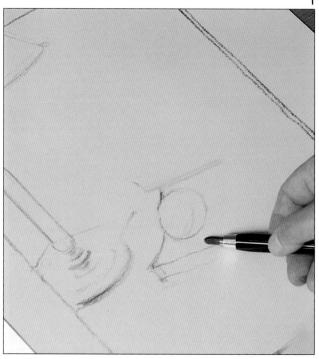

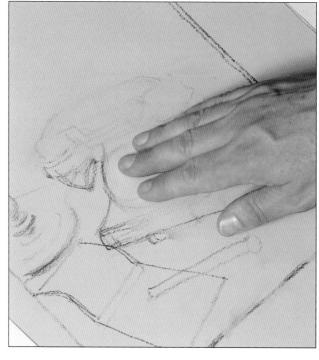

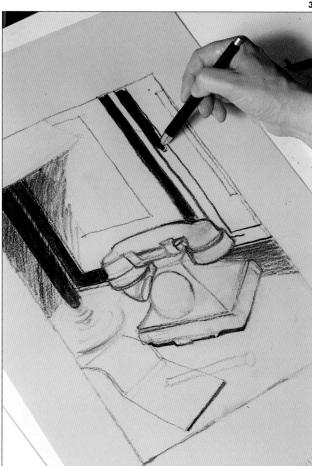

- A grey Ingres paper has been chosen for this project because its colour will become an integral part of the drawing. Apart from forming a useful mid tone against which to judge the strength of the lights and darks in the image, a tinted paper also prevents the 'whites' - such as the lampshade, telephone and notebook – from appearing too stark and disrupting the tonal harmony of the drawing. Using your thumbnail sketch as a guide, start to lay down the initial outline drawing. Keep the charcoal lines light and loose at this stage – notice here how the artist holds the charcoal pencil from beneath, his hand well back from the drawing point.
- 2 As you sketch in the main elements of the drawing it is always worth standing back as you complete each one, just to make sure that you are happy with its shape and position. The beauty of charcoal is that alterations and

- corrections can be made simply by gently rubbing the lines away with your fingers. Any pale marks which are left will be absorbed into the drawing as it progresses.
- 3 You are probably wondering by now why the artist does not appear to be using a charcoal stick. In fact he is, but it is enclosed in a stub holder. This is a handy device which can be adjusted to take virtually any thickness of charcoal stick. Willow charcoal can be quite fragile and prone to breaking if you apply too much pressure on the stick. With a stub holder this problem is avoided and you have greater control over your work. In addition, a stub holder keeps your hands clean and thus reduces the risk of accidental smudging. Once you have sketched in all the elements of the drawing, start to fill in the background and add the darkest areas - the picture frames and the lampstand.

CHARCOAL / OLD TELEPHONE

4 The table top is very similar in tone to the lampstand, so work carefully here to keep it just a shade lighter and prevent the lampstand from becoming 'lost'. At the same time, indicate the contrasting texture of the grain of the wood on the table top. If you are using a stub holder do not be tempted to hold it too tightly or you will lose that naturally loose and spontaneous feel that charcoal affords.

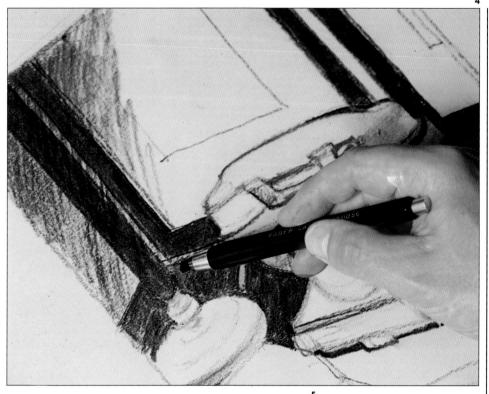

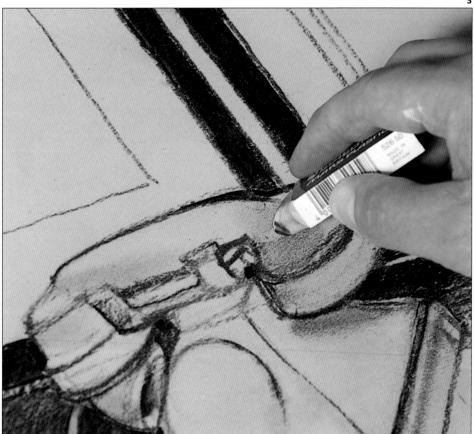

At this point it is a good idea to fix the whole drawing. This will allow you to continue working on the piece without smudging what you have done so far. When the drawing has dried, start to develop the three-dimensional form of the telephone. Add the shadow inside the mouthpiece, softening the charcoal mark with the tip of your finger. Then, using a kneadable eraser and without applying too much pressure, gently smudge some of the charcoal lines on the handset to create the softest of tones in the shadow areas. Do the same with the shadow cast by the handset onto the body of the telephone.

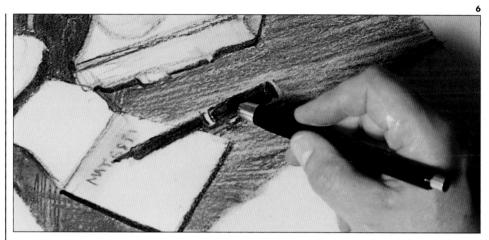

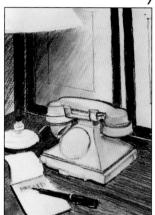

6 With the charcoal stick, lay in the foreground area of the table top. Use closely hatched strokes, but work lightly and loosely to give an impression of the grain of the wood. Write in the telephone number on the notepad, then fill in the fountain pen with a dense, dark tone, leaving the metal details white.

7 Before you continue any further, this is a good point at which to step back and take an overall view of your drawing so far. Referring back to the original reference you will see that more shading is needed over the left-hand corner of the picture where the lampshade throws a shadow. Work this part of the background up with

light hatching strokes, but be careful not to make it too dark as it will throw the picture off balance. Notice how this area of darker tone throws the telephone into relief and brings it forward in the picture plane.

8 Once you are happy with the background it is important to fix the whole drawing again to prevent any smudging as you work on the final details. Sketch the figure in the frame on the wall, then resume work on the telephone. Sketch in the central circle and the finger holes on the dial.

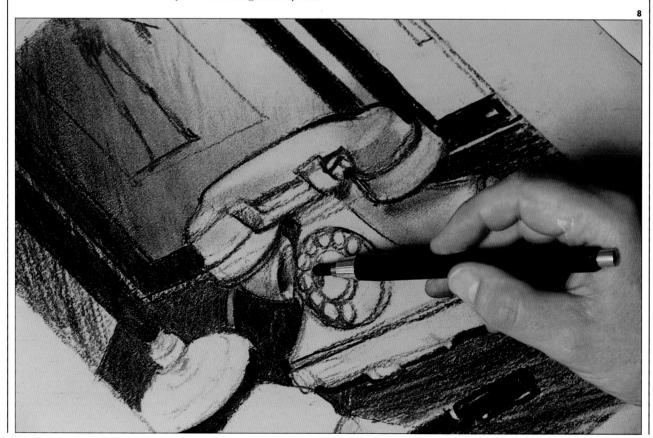

CHARCOAL / OLD TELEPHONE

9 Fill in the circle of the dial but do not worry about the letters in the finger holes, as such fine details tend to 'leap out' and distract attention from the rest of the picture. Now that the darks and mid tones are established, it is time to bring the drawing 'into focus' by picking out the highlights. Here the artist is using a stick of white chalk to render the highlights on the shiny surface of the telephone.

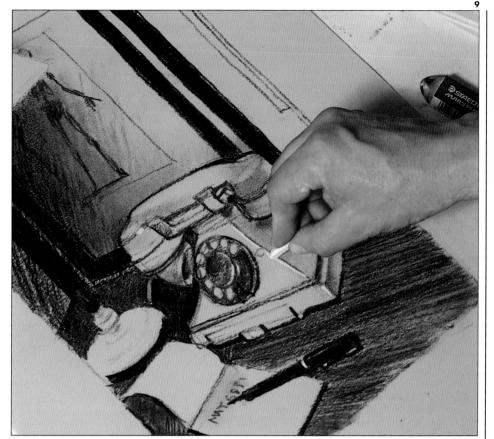

10 This detail from the drawing shows how the addition of a few well-placed highlights can really make a picture 'sing'. Fill in the base of the lamp with charcoal, carefully following the lines you originally sketched in. Then use the white chalk to pick out the highlights on the base, pressing hard with the stick to make them quite strong. If you refer back to the original photograph you will see that the highlights on the lamp base are clear and sharp, whereas those on the telephone are softer and more subtle.

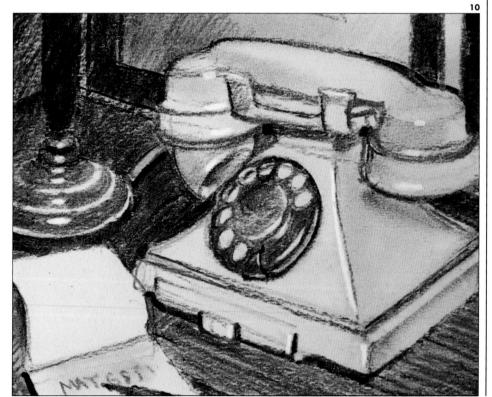

11 At last you can stand back and assess your finished drawing. If you are not completely happy with it, now is the time to do any final 'tweaking'. However do not be tempted to overwork any details, as this could easily spoil the overall effect. Bear in mind that the main appeal of charcoal lies in its loose, sketchy quality – so try to

work quickly and with spontaneity. Even in a drawing like this where there are several elements involved, the actual rendering should have taken you hardly any time at all. Finally, do not forget to fix your drawing, otherwise it could be reduced to one big smudge before you get a chance to frame it and hang it on the wall!

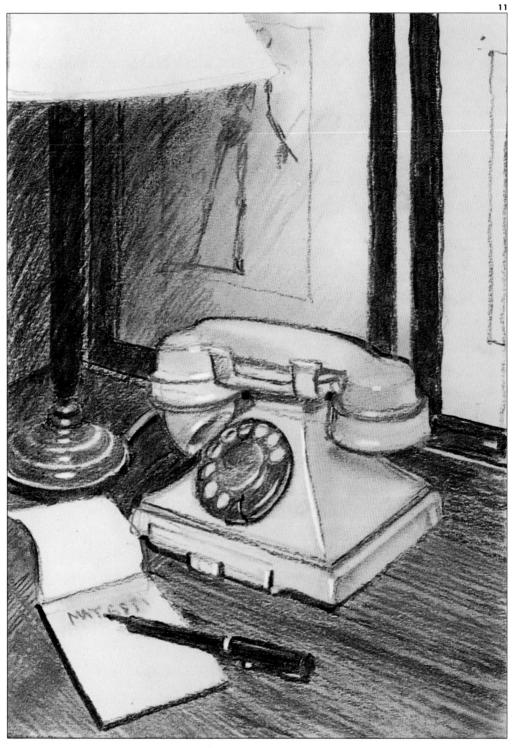

Venetian Washing Line

INK

As we explained in chapter 2, still life falls into three distinct categories – randomly placed 'found' objects always being one that people have problems seeing as a true still-life form. This is especially true when the objects have been found outdoors. Although some people might argue that this project is not a 'proper' still life (i.e., a group of objects carefully arranged against a background), this scene is so striking that we felt we could bend the rules slightly to include it. Draped material often plays an important part in a still life, and, anyway, due to the lack of a breeze, this washing line was still when the photograph was taken!

As an artist you must be aware of the importance of carrying a camera or sketch book around with you whenever possible. This helps you to build up a visual 'library' of reference so you will never be short of something to paint. This was the case here. The artist was on holiday in Venice and while out sightseeing he chanced upon this intriguing view which has an almost surreal feel to it.

What appears to be a very simple scene, holds a multitude of challenges for any artist, with all the various textures of the crumbling plasterwork, the weatherbeaten bricks, the shuttered windows and the crisp white shapes of the shirts on the washing line and the perfect shadows they create.

In fact this particular image could be rendered in any medium but the artist opted for a monochromatic interpretation in ink using fine liners. Given the essentially linear, uncompromising nature of fine liners, this may seem a strange choice. But the artist welcomed the challenge of producing a range of subtle tones by building up a network of hatched and crosshatched lines, working from light to dark. As you will soon discover, this is really quite a satisfying and surprisingly simple approach which results is a wonderfully detailed finished drawing.

Throughout this project you will in fact be using two pens – one new and one old. An old pen contains less ink, therefore it is easier to control than a new one and allows you to make a cautious start 'feeling' your way into the drawing. With a pen drawing once you make a mark on the paper, you are stuck with it! Therefore a gradual approach is a sensible one, allowing you some control over the build-up of tones and textures.

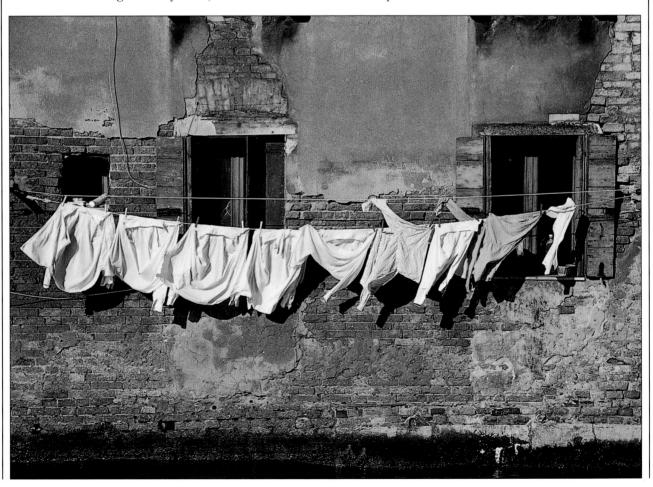

- Your chosen support for this fine liner rendition should be a reasonably heavy, smooth cartridge paper, which allows the pen nib to glide easily over the surface. Start by making a a fairly tight pencil sketch of the subject, following the original reference. This will act as a guide, but apply only light pressure with the pencil as you do not want these marks to show through in the finished drawing. With your old pen, start defining the shapes of the washing line by blocking in the shadows cast on the wall behind them using hatched and cross-hatched strokes. These initial strokes will be further defined as the drawing progresses.
- 2 Now move on to the windows behind the washing line. Switching to your new pen, define the darkest shadows using dense crosshatching strokes. Unlike the shadows in step 1, the shape of the windows are rigid and well-defined you may find it helpful to use a ruler to achieve clean, straight edges.

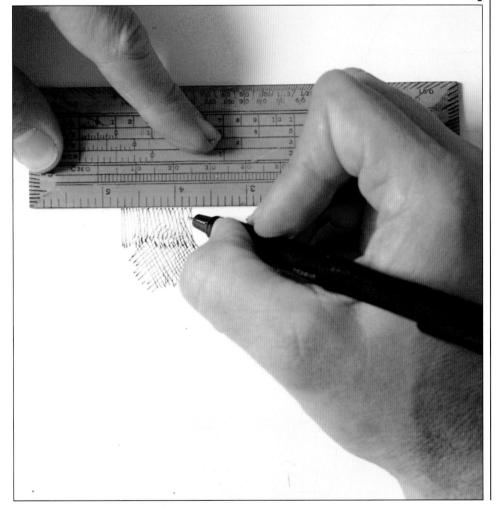

43

INK / VENETIAN WASHING LINE

3 Sticking with the new pen, return to the shadows behind the washing and go over them to sharpen them up. You could have used a new pen initially, but the first marks of any drawing are always the most nerve-racking,

and this method allows you the opportunity to gain a little more confidence as you gather momentum. The shapes of the shirts on the washing line are established by the 'negative' process of defining the surrounding shadows.

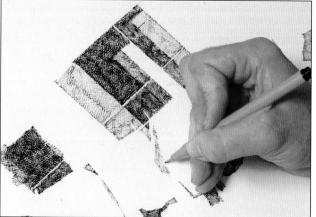

4 Switching back to the old pen and again using a ruler to define the straight edges, add in the lighter areas of the window. The reason for working in the darker tones first is that when you come to do the lighter tones, you do not have to be quite so precise. After all, if any of the lighter lines do run over into the darker areas, no one will notice! Another advantage of using an old and a new pen is that you have a choice of dark and light tones. Moving back to the washing, start to add in the lighter shadows between the shirts and in the folds of the material with closely hatched strokes.

Now your drawing is really beginning to take on some shape. With the old pen, start to define the brickwork. In an old building, the bricks are not neat and tidy. This is to your advantage as they will not have to be rendered precisely, so it will not be a tedious job. As you can see from this detail, a lot of random work is being done. So have some fun and use a mix of cross-hatching, hatching and scribbled strokes. Some of the bricks have a straight edge, which has been created with the aid of a ruler, but this combination of tight and loose work - when you stand back will have created the illusion of bricks worn and crumbled due to the effects of age and weather.

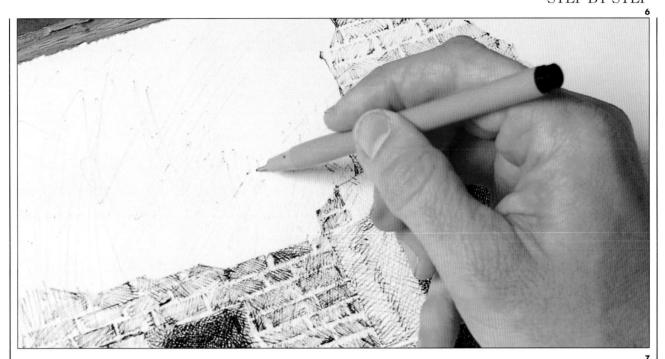

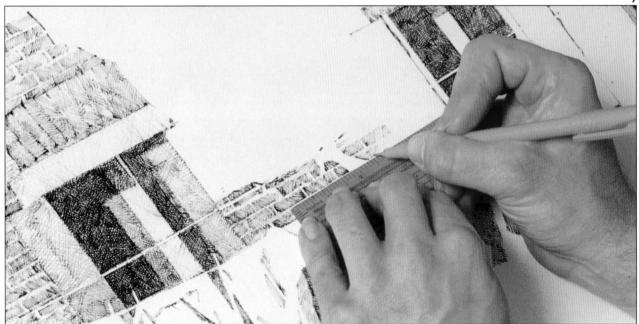

6 This is one of those drawings where, if you become bored with one area, there is no reason why you should not move on to another area. Again using the old pen, begin to add the cracked and crumbling plasterwork of the building. Only a suggestion of line work is necessary here, so very

loosely hatch in the areas to the left. By now you should be getting a real feel for the medium, and gaining plenty of confidence as your drawing takes on a new dimension at every stage. 7 Switching to the new pen, and again using the ruler, add in the darkest areas of the window on the right-hand side. Continuing with this area, change to the old pen and finish off the lighter areas of the window and complete the rest of the brickwork as well as the outline of the shutters.

Once again use a combination of loose hatching and precise, ruler-aided work. In this drawing you will notice how the white of the chosen support is used to its full potential. Whole areas, such as the shirts, are given their form purely from the shadows that are rendered around them.

INK / VENETIAN WASHING LINE

8 With the old pen, fill in the rest of the plasterwork using the same technique as in step 6. At this stage it is wise to a step back from your drawing and assess your progress so far. You will notice that now that the brickwork is complete, your original shadows around the shirts are slightly lost. Return to them with the new pen and crosshatch over them once again.

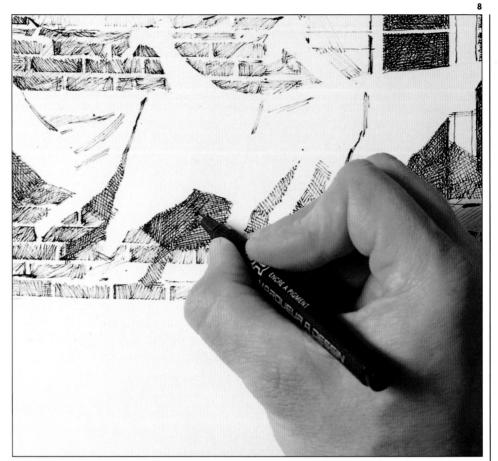

9 The top half of your drawing should by now be looking fairly complete. However, the lower part is totally empty and it is important at this stage to obtain a correct overall view of your drawing and to create the right sense of balance. With your trusty 'old' pen, start by defining the line of the building where it meets the water, using densely hatched strokes.

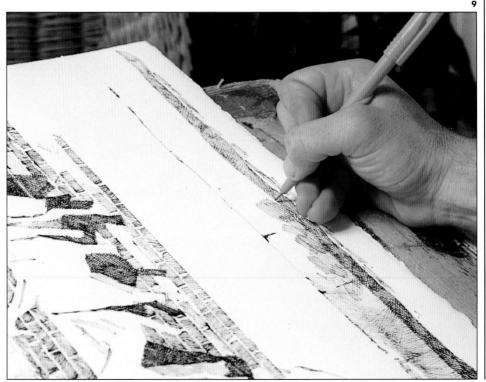

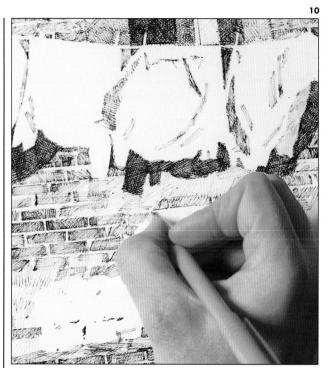

- 10 Apart from the waterline mark the whole of the lower area of the building is made up of odd patches of plaster and brickwork which have been eroded away over the years with the coming and going of the tides. Therefore your rendering can be fairly loose, using a combination of hatching, cross-hatching and scribbling, but always referring back to the original reference.
- 11 At last you have reached the best stage of every drawing or painting when you feel it is complete! Avoid the temptation to overwork the drawing. Often it is best just to walk away from it at this point and return to it at a later stage, when your involvement with it

has decreased and you can view it from a more objective standpoint. The completed drawing shows how crosshatching can be used to produce carefully controlled effects, particularly when using fine liners. Yet the finished result, far from being stilted and dead, has a lively, animated feel because the artist worked quickly and intuitively. Working with a medium which you have no real way of correcting – once you have made your mark – is a pretty nerve-racking experience. However, hopefully you have succeeded and at the very least learnt how to put an old pen to good use!

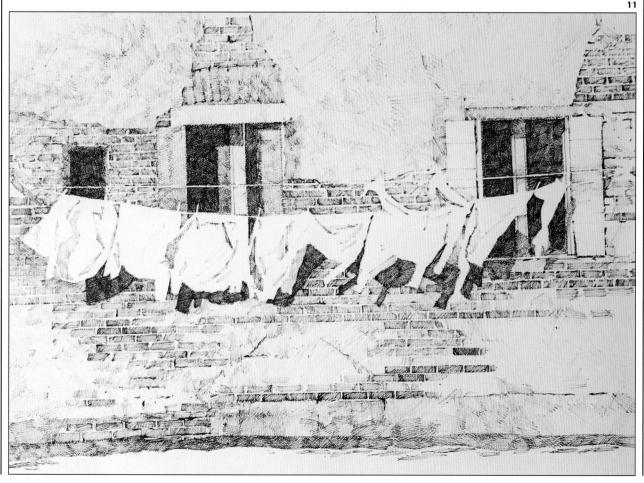

Chapter 4 Dry Colour

In the previous chapter we started you off with projects that did not involve colour, but were aimed at improving your basic drawing techniques. Now we are going to progress onto the next stage which employs drawing but in colour. This is the meaning of the term 'dry colour'. It can be used when referring to any medium which is capable of producing a coloured drawing, but we have chosen pastel and conté pencils for the two projects here. These media will present you with two totally contrasting ways of working.

Conté has been around for years but in the form of crayons, or sticks. In this form it can be used in a similar way to pastels and was utilized by many famous artists including Toulouse-

Lautrec. However in more recent years the sticks have been encased in wood, which makes them appear more like coloured pencils. The similarity stops there because conté is so much softer and chalkier. Therefore you have the advantages of a soft medium, constricted in a case, which in turn means that your approach will have to be tighter.

Pastels, on the other hand are exceptionally versatile and may be used as a drawing or painting medium. They have been a great favourite with artists for many years, gaining popularity with their use by the French Impressionists. Their spontaneous, easy style is rather similar to charcoal, which makes them ideal for an introduction to colour work.

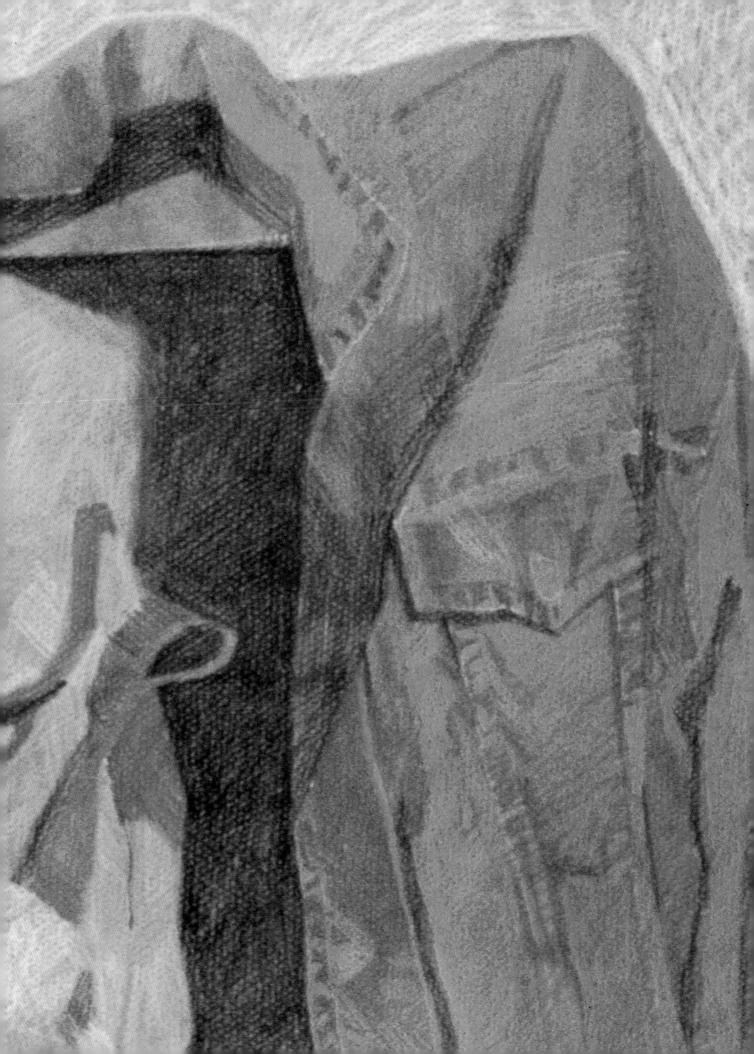

Materials

CONTÉ PENCIL AND PASTELS

Conté Pencils

Traditionally, conté was only available in the form of oblong sticks and in a restricted colour range of black, white, grey, sanguine, sepia and bistre (earth colours). Nowadays they are produced in a wide range of colours and – like pastels – are also available in pencil form.

Conté pencils are made from pigment and clay bound with gum which is pressed into rods and encased in wood. They are softer and less waxy than ordinary coloured pencils, but not as soft and crumbly as pastels. Because they can be sharpened to a point they are ideal for detailed linear work – and are less messy to use than conté crayons. As with coloured pencils they can be bought individually by the stick or in boxed sets of assorted colours. This is useful as it enables you to start out with a basic set and then add to it as the need arises.

Pastels

Pastels are made from pure pigments and chalk bound with gum and moulded into square or round sticks. They come in three grades – soft, medium and hard – the soft grade containing more pigment and less gum. Soft and hard pastels each produce a different range of textures and effects, and the two types can be combined quite happily, and to good effect, in the same painting.

The nature of pastels does not allow you to physically mix the colours, so they are available in every hue and shade under the sun. This can make it difficult when you come to choose which colours you need, but you can buy boxed sets of assorted colours. Some of these even comprise selected colour ranges covering specific subjects such as landscapes, portraits and still life, which should help you immensely. Be warned though, they are exceptionally messy to work with.

Oil pastels have an added binder of oil so they are not as crumbly as pure pastels and do not smudge. They respond rather like oil paints so you can work into them with a brush dipped in turpentine for a wash effect.

Supports

When working with pastels or conté pencils remember that the colour of the paper will play an important part in your finished picture. This is because dry colour sticks are worked loosely and sketchily rather than in solid blocks of colour, therefore the colour of your support will inevitably show through in some areas. So try to choose a tinted paper which either harmonizes with your subject or provides a contrast.

Because of their slightly powdery texture, pastels require a paper with enough texture, or 'tooth' to hold the pigment particles in place. Ingres paper is perhaps the most suitable as it is available in a wide range of colours and has a rough surface. In fact any paper that has a textured finish – even fine sandpaper – can be used. Conté pencils, being less powdery, can be used on a smoother grade of paper.

Other Equipment

When working in pastels you will need to spray your work with fixative to bind the pastel particles to the paper and protect it from smudging. Another handy tool is a large, soft brush to brush away any excess dust which is invariably left when working in such powdery medium. A torchon (a stump of rolled paper) is useful for blending pastel colours, though a rag, cotton bud or your fingertip would do the job just as well. Finally, you will need a scalpel or craft knife to sharpen the points of conté pencils and pastel sticks.

MATERIALS

Techniques

CONTÉ PENCIL

The beauty of conté pencils lies in the infinite range of colours you can achieve through optical mixing. When working in conté pencils colours cannot be physically mixed together on the palette as they can with paints, but

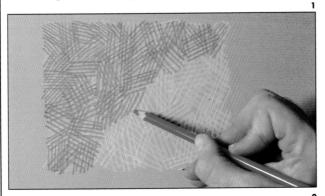

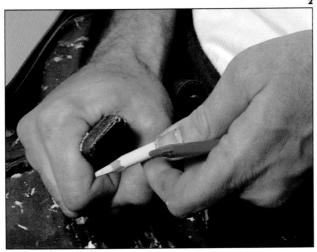

a whole range of colours can be achieved through optical mixing – laying one colour over another. From the appropriate viewing distance these colours appear to blend together, but the effect is more vibrant than an area of flat colour because the strokes are broken up.

Crosshatching

Crosshatching is basically a way of optically mixing colours in a very clean and crisp way. Carefully crosshatch over the entire area with one colour and then crosshatch over it in another colour (1). It is important when using this technique that your pencil is always sharp (2) and this is best done with a stanley knife or sharp blade. Apart from creating an interesting textural effect the overlaid strokes produce colour mixes where they intersect with each other.

Pointillism

Pointillism is a way of building up an area with small dots of pure colour and comes from the French word point meaning dot. The dots are closely spaced, but not joined, allowing some of the toned paper to show through. Start in one colour and fill the area with dots. Change to another colour and add more dots to the spaces left by the first colour. From a distance these dots appear to merge into one mass of vibrant colour.

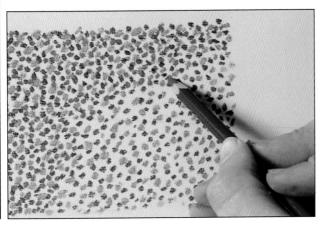

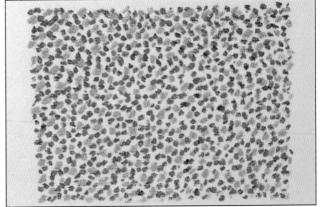

PASTEL TECHNIQUES

Linear Strokes

If you have never used pastels before it is important to practise the various strokes that are achieved by using the stick in different ways. Using the flat end of the pastel (1) produces a band of colour as thick as the pastel. By sharpening the pastel to a point (2) you will get a very thin, sharply defined line. Finally, using the pastel on its side (3) produces a broad band of colour which is perfect for filling in large areas.

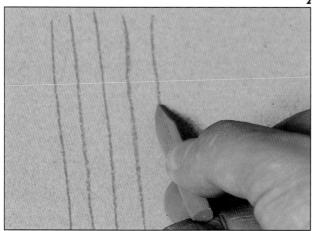

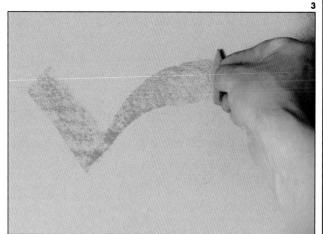

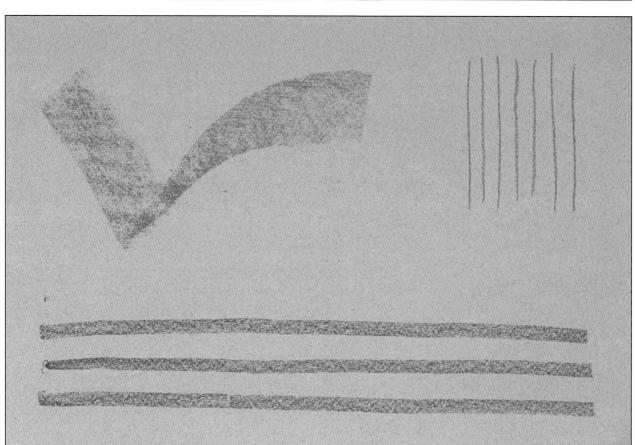

PASTEL

Scumbling

Scumbling is a term used to describe the technique of mixing colours optically by laying one colour over another. Start by laying a loose tone of colour from the left-hand side, then change to another colour. With this second colour begin from the right and continue until it crosses over the first colour. Where the colours overlap they mix giving the illusion of a third colour.

Scribbling

Scribbling over a tone of one colour with another is simply another way of mixing colours when working in pastels. Here we have chosen to illustrate light over dark, but this technique is just as successful with dark over light. Lay an overall tone in a dark colour with the side of the pastel, then switch to a lighter colour (1) and loosely scribble over the top. Changing to an even lighter colour (2) – in this case white – loosely scribble over the first two colours. You now have two different tones which have been created by allowing all the colours to show through.

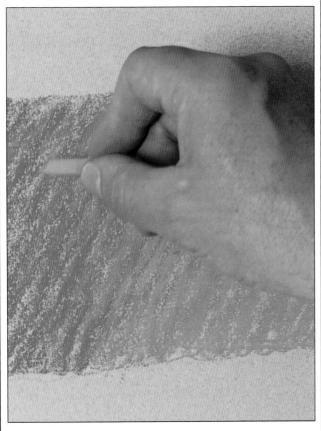

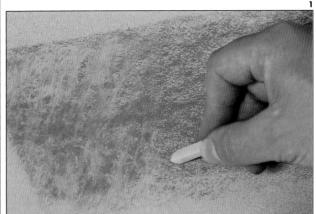

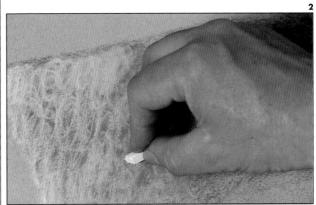

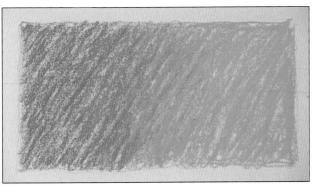

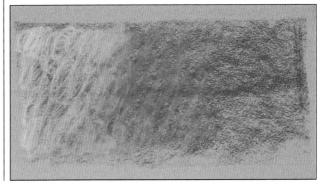

TECHNIQUES

Crosshatching

Crosshatching is not normally used when working in pastel, but because this is an experimental stage it is worth doing since it illustrates another way of mixing colours. It also produces a very clean and linear effect which provides a contrast to the naturally soft finish of pastel. Build up an area with regular lines in one colour, then change to another colour and, with the same regular lines, go over the first colour but in the opposite direction. Here the lines are fairly wide apart but they can be drawn much closer together depending on how dense you want the colour to be.

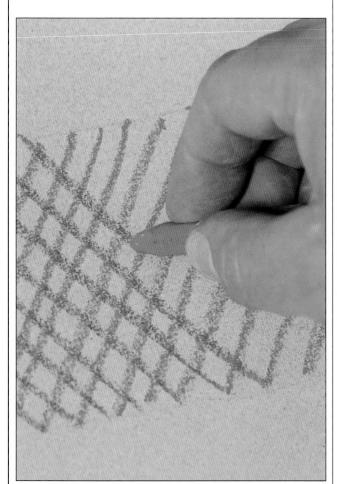

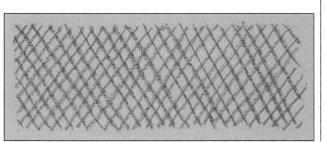

Blending

As you can see from the previous techniques when one pastel colour is drawn over another they will naturally blend on the paper to form a mixed colour. In reality this is optical mixing, but it is on such a fine scale – as the particles of pastel colour mix together – that it appears to be an actual mixing of colours. Loosely scribble in an area and then change to another colour. As you cross over you will find that it picks up and blends with the colour underneath. These can be further blended by gently rubbing over the area with your finger, a torchon, a brush or a piece of tissue. This merges the two colours to produce a subtle and smooth transition of colour.

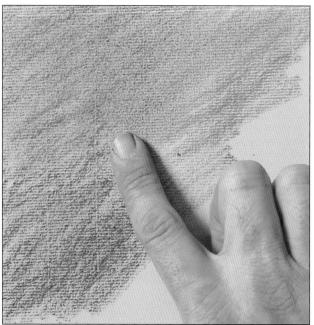

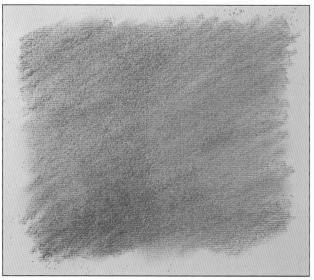

Satchel, Hat and Coat

CONTÉ PENCIL

Within each of the projects chosen for this book we have tried to present you with a wide variety of textures to depict. This is not only to give you fresh challenges, but to show you that a still life can be composed from any range of objects, whether indoors or outdoors.

For this drawing project we chose a small group of everyday objects – a folding chair, a denim jacket, sunhat and canvas satchel. The group has a spontaneous, unplanned feel, as though someone has just re-turned from an afternoon's sketching.

The artist is lucky to have a terracotta floor which provides an interesting background to many of his still-life compositions. It goes to show that you should always make use of what you have around you – even the floor!

The linear nature of conté pencils does not lend itself to rendering solid blocks of colour, but although the style of this drawing is quite loose and sketchy it is still possible to create the illusion of solid objects. This is why the colour of your chosen paper is so important, as you will find out in this project.

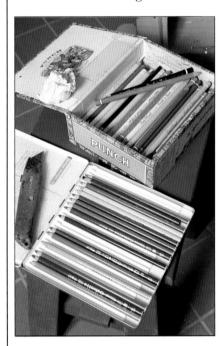

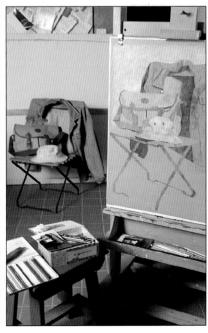

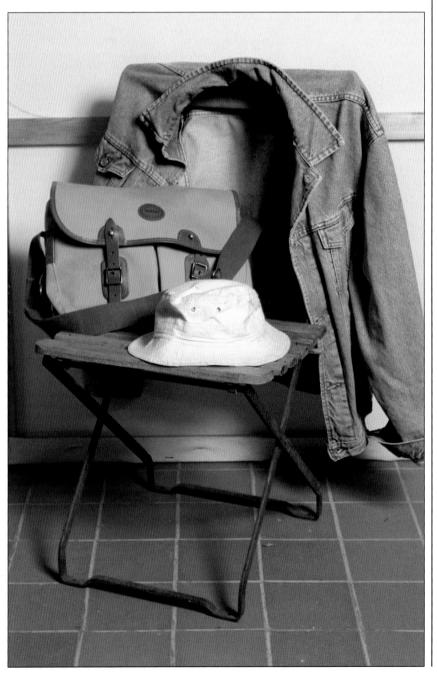

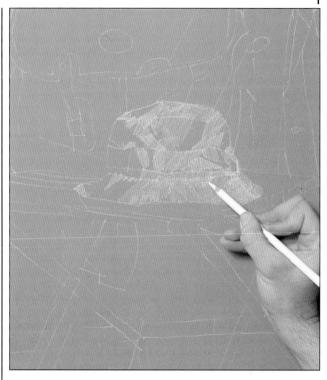

1 When working in a dry medium like conté it is important to choose the colour of the paper carefully. This is because you will be using it, not only as your background colour, but also to enhance and bring out specific areas of your drawing. Conté pencils do not readily lend themselves to

creating solid blocks of tone, so it makes sense to choose a coloured paper that will serve this function and relieve you of much of the hard work! The choice here was a mid-brown pastel paper which tones in with the bag, the canvas stool and the tiled floor. Draw the outlines of the group with a

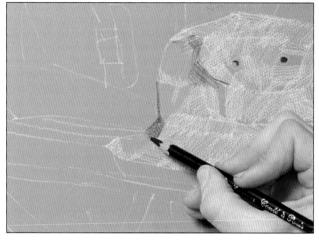

white pencil, which will show up against the relatively dark paper. Make the drawing quite detailed, mapping out such things as the shadows and folds of the material as this will make your drawing much easier to build up. As you are already holding a white pencil, what better place to start than with the white of the hat. Following your initial drawing, start to fill in the contours of the hat using the technique of crosshatching (see page 52).

2 As you become more skilled at using your 'artist's eye', you will realize that a

white object is never truly white but contains a wide range of tones, from light to dark. Often it will also contain hints of other colours; this is because white is highly reflective and picks up colours from surrounding objects. Here the colour of the canvas satchel is reflected onto the hat, so pale yellow and pale green pencils are required. Crosshatch these colours following your initial drawing and referring back constantly to the actual object in front of you. Once you have completed the reflections, hatch in the shadows in black.

With the black pencil, lightly indicate the main shadow areas, particularly inside the jacket. Use multidirectional crosshatched strokes to bring a lively texture to the drawing. Just by doing this you will have already given a certain amount of form to the objects. Switching to a mid-blue pencil, move on to the denim jacket. With loose crosshatching start to block in the folds and creases. At this point keep your hatching light as you will be returning to the jacket at a later stage; If the lines are too dense at first. you will find it difficult to build up colour and tone in a controlled way.

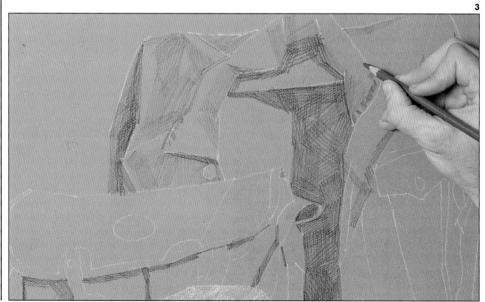

CONTÉ PENCIL / SATCHEL, HAT AND COAT

- 4 Block in the lighter areas on the satchel with a yellow ochre pencil, using loosely hatched strokes that follow the form of the folds and indents. When you move around the picture like this, it is so much easier to get an overall feel for your drawing. Already all the individual elements are taking on form, and by working in this way, you will be able to see more clearly which objects will need to be worked up more fully.
- Block in the strap of the satchel with a mid-green pencil, then use a light blue pencil to block in the highlights on the denim jacket. In this drawing there is no main focal point, so all the objects in the group must balance each other. This is why you have been working on the drawing as a whole, rather than concentrating on one element at a time. Besides, if you spend too long on one object it could put you off finishing the drawing, when you realize you still have four more objects to render to the same degree!
- 6 Now block in the squareshaped highlight on the inside of the jacket with a light blue pencil. Draw the button, and the highlights on the edge of the collar, with the white pencil. With the black pencil, strengthen the main shadow at the back of the jacket. Then add the shadow beneath the collar and bring out the creases and folds in the material.

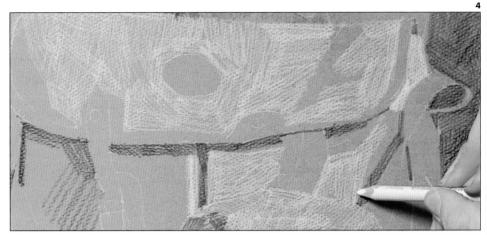

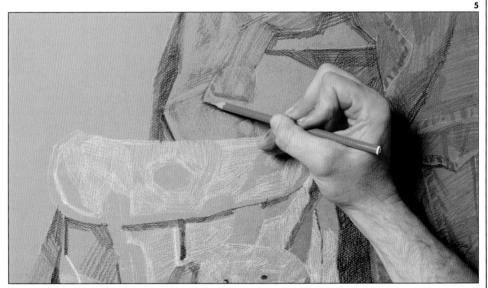

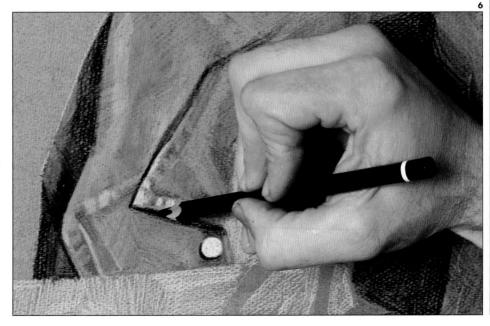

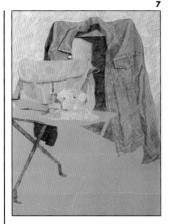

7 Start blocking in the legs of the chair in black, using light crosshatching strokes, and fill in the sleeve hanging down below the chair. Switching to a white pencil, loosely crosshatch a white background in around the top half of your drawing. At this stage, stand back and take a good look at your work so far. It is incredible what a

difference the white has made. Not only has it succeeded in defining the outline of the jacket, but it has also thrown the whole group forward in the picture plane.

8 When filling in the precise shapes of the chair legs, you may find it useful to use the edge of a ruler as a guide, allowing you to hatch against it rather than being tempted to draw a rigid line along it which would create a hard edge. This is not cheating and means you can draw the strokes freely without worrying that they will go over the edges desired.

Switching to a deep vellow, start to block in the darker areas of the satchel. You can do this with loose hatching, sometimes going over the paler areas, which will make the bag appear more natural, giving you a range of subtle tones rather than a solid, lifeless feel. Now it's time to tackle the leather trim, using a mid-brown pencil. These areas are more solid so block them in loosely, but this time use a little more pressure on the pencil. To bring out the sheen and density of the leather, switch to a dark red pencil and add some subtle patches to highlight the straps and then work up the shadow areas with black.

CONTÉ PENCIL / SATCHEL, HAT AND COAT

10 You are now on the final stages of all the objects. Using the black pencil for the last time, block in the shadow cast by the hat on the seat of the chair. Now take stock of your drawing and go over any shadows that you feel need to be strengthened.

11 On looking at your picture as a whole – even

though the floor tiles have yet to be tackled – the white background has created an uneven balance between the upper and lower halves of your picture. To rectify this, use a mid-grey pencil to loosely block in the lower half of the wall behind the chair, which is in the shadow. Now you can start on the tiles, using a mid-brown pencil. Use the ruler

once again, this time to define the straight lines of grouting between the tiles.

12 In keeping with the sketchy style of the drawing, there is no need to render the tiles perfectly. Never be tempted to overwork a drawing of this style. Instead, loosely block in the rest of the tiles as if you are almost

scribbling. Hold the pencil right at its end to give you a really loose mark on the paper. To give an impression of light and shade falling across the floor, vary the tones of the tiles, making them darker immediately beneath the stool.

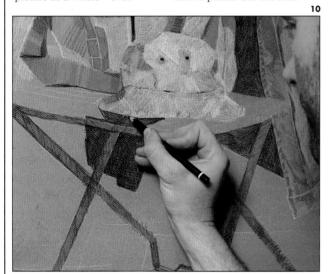

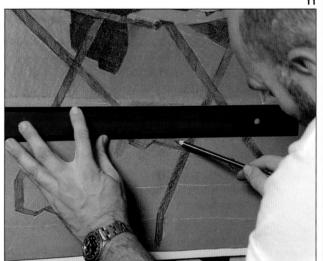

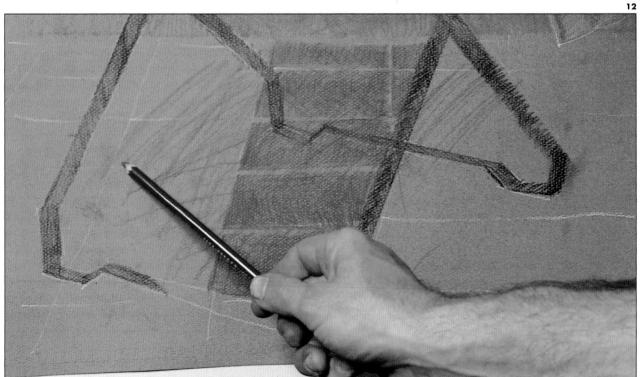

13 Once you have completed the tiles, step back and take a final view of your drawing. If you feel anything needs going over do it now, but do not spoil the sketchy feel of the image by being tempted to overwork any specific areas. Now you can see what an important role is played by the colour of the paper; not only does it serve as the base colour for the floor, the satchel and the canvas seat of the chair, it also pulls the whole drawing together and creates a sense of harmony and unity. In addition, these areas of bare paper provide 'breathing spaces' in the drawing, enhancing its sketchy, spontaneous feel.

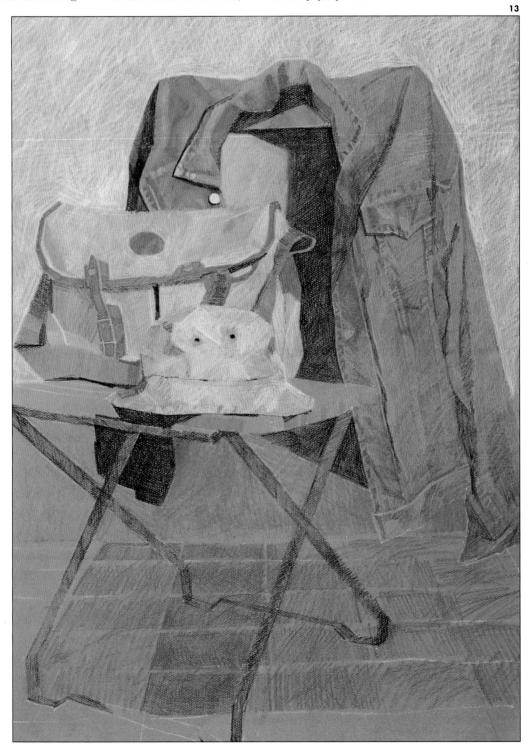

Flotsam and Jetsam

PASTEL

Here we have a perfect example of a 'natural' still life (explained more fully in chapter 2). This heap of flotsam and jetsam lying at the high tide mark on the beach was not at first an obvious choice for a work in pastel; however, the drab colours in the old wood did, on closer inspection, lend themselves readily to a rather moody depiction – something pastels can be very good at.

The aim of this project, therefore, is not only to get to grips with pastel techniques, but also to gain experience in capturing the mood of a scene. In this particular case the artist decided not to include any of the people sitting on the beach, so as to focus attention on the group of objects and to emphasize the sense of isolation. This mood is further underlined by the use of a limited 'palette'. The colours in the group are echoed in the pebbles on the beach. This not only evokes a quiet, restrained mood but also creates a uniformity of colour which helps to pull the whole composition together and give it strength.

Pastels are renowned for being a 'fast' medium, but they are also suited to a slower, more considered way of working. This project will demonstrate that you can take your time when using pastels, working towards a fairly 'finished' effect while losing none of the vibrancy and expressiveness for which they are so admired. The beauty of pastels is their ambiguity, and when you can harness this, the rest is easy.

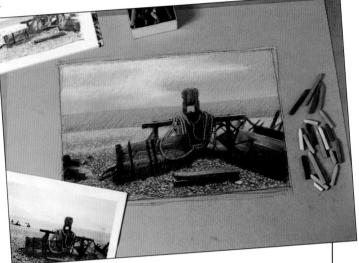

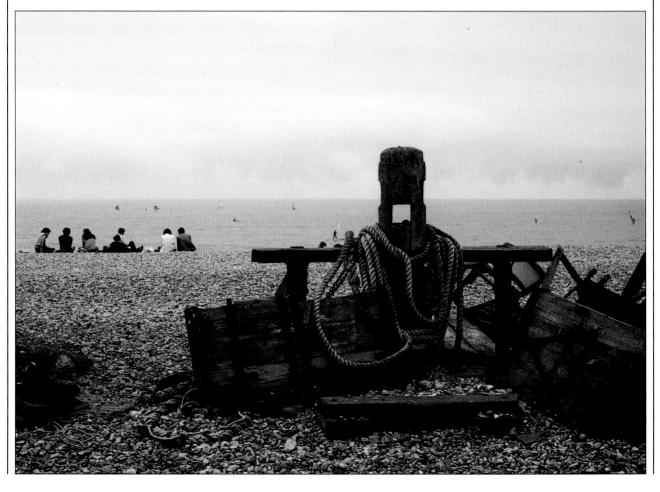

- 1 In this case the artist made a quick thumbnail sketch in charcoal before starting on the work in pastel. Although this stage is not imperative and it is stressed that you do not have to follow any of the projects in this book religiously if you do decide to do the same you will discover that it is a wonderful device in establishing the composition often the most difficult part of any still life.
- 2 The first true stage in this project is to use the charcoal to roughly mark out the area to work in. This has the effect of limiting your work

to the confines you set up at the very beginning and so will stop you getting 'lost' later on, especially if working on a large piece of paper. When working in pastels, the colour of the paper itself will nearly always affect the end result. In this case a muddy green colour is ideal, since it can be used as the base colour for the pebbles on the beach.

Start by marking out the various elements of the picture in different colours to give a wide variety of hues later on. These colours will largely disappear as your work progresses, but they do help to 'set the scene'. Use a deep maroon to mark the horizon and a dark blue for the shoreline. Then, using the side of the sticks, start blocking in the major elements - the flotsam and jetsam overlaying orange, blue and deep maroon to build up colour and form.

Continue working up this area, blending and overlaying colours as you go - some deep green, Prussian blue and ultramarine will be perfect. This mixture of colours may seem strange – especially since in the finished picture very little will still be obvious – but they are very important in creating a sense of colour harmony in your work. These colours will be evident elsewhere, and the minute traces of them in these first areas will help pull the whole picture together. As we mentioned in the introduction to this project, the long piece of wood running along the shoreline needs to be moved slightly to avoid a confusing composition. Make sure that you block in its new position at this early stage since it will be much more difficult to alter later on.

PASTEL/FLOTSAM AND JETSAM

4 Using the side of the pastel sticks, fill in the sky area with bands of sky blue and white. You can then gently blend the whole of the sky area with the tips of your fingers to create a soft, slightly hazy, blur which will be built up further later on. Then use turquoise blue and sky blue to roughly mark in the sea with scribbled hatched strokes. This is also an ideal opportunity to add more

body to the main group of objects by blocking over them with burnt umber.

5 It is now time to start making more positive decisions about the picture by defining and outlining the objects. Although a dark tone is obviously required to separate the group of objects from the background, black would probably be too harsh and

overstated for such a picture. Therefore, use a dark blue – which again maintains the colour harmony – to go round and mark in the various outlines, not forgetting those of the coils of rope. Make sure the pastel is sharp, and use the very tip for these lines so that they can be easily altered later.

6 Now that the group of objects is firmly in place, start

working on the pebbles. Begin with the large oval pebbles in the foreground, working back to the merest suggestion of form near the shoreline. Go over the area three times, firstly with brown, then dark blue and finally maroon, dotting in pebbles here and there with each successive pass-over. You will be returning to the pebbles at a later stage.

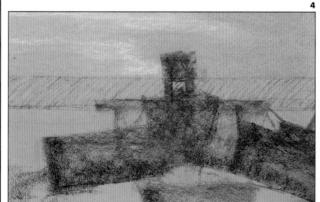

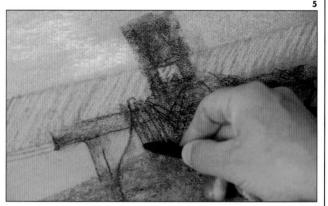

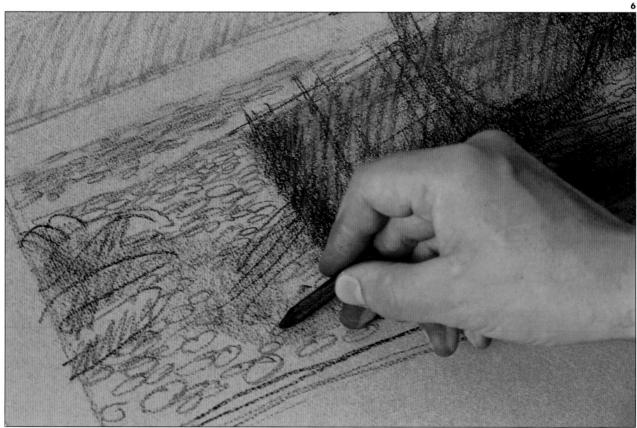

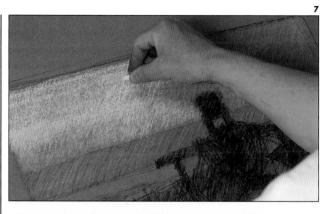

- 7 Since all the major elements of the picture are now in place, it is possible to finish off some of the background details. First to receive attention is the sky. Using white, hatch over the cloud area you suggested earlier until the white has quite a bit of presence. Then hatch over the remainder of the sky with sky blue and a small amount of yellow.
- 8 Once you have finished blocking in the sky, gently blend the area with your fingers. The hatched strokes have deposited a large amount of colour onto the paper which, when blended, provides a great depth of tone. This technique gives a more lively effect than using the side of the stick to block in an area of thick colour, which tends to create a rather 'flat' and lifeless look.

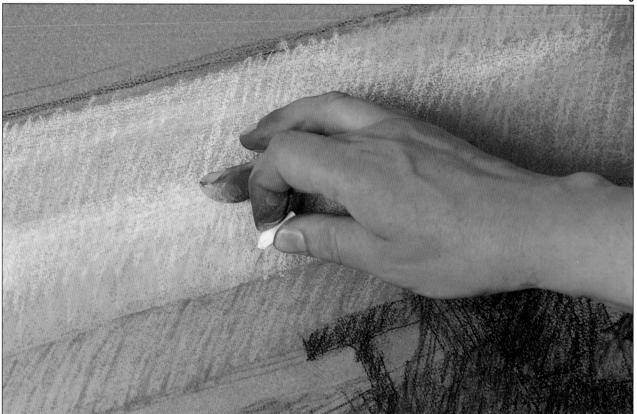

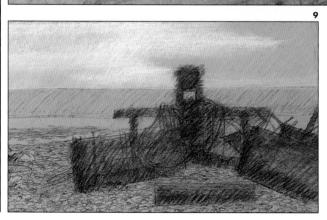

9 The sky is completed by adding a little more white again and then blending this in with long, thin strokes to imitate high, spindly clouds. Now the sea can be gradually built up by overlaying strokes of sky blue and a dark blue/green over the initial colour. Keep a close eye on what you are doing, and stop the moment it looks alright. If you put down too many layers

you will end up with a muddy colour and a surface that is clogged and 'dead'.

PASTEL/FLOTSAM AND JETSAM

10 With the sea and sky completed, return once again to the pebbles. As mentioned earlier, colour harmony is very important in any picture. You have already included dark blue, brown and maroon pebbles, so, you should now continue with the other colours used elsewhere in the picturegreen, orange, sky blue and yellow. Not only will this maintain the unity of colour, it will also provide more interest in the foreground (in reality the

pebbles were rather dull and monochromatic, but a little artistic licence is permissible in the interests of creating a lively image!).

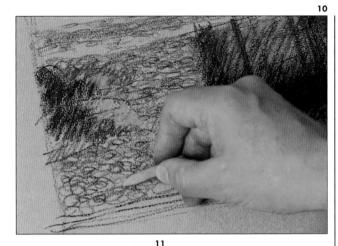

white to the rope as an indication of hue, completes the final base colour. From now on you will be working on the details, so it is important to fix your picture at this stage, to avoid smudging the underlayers. In this photo the artist is using a mouth diffuser, but fixative is also available in CFC-free aerosols which are easier to use (but be warned, the smell is rather overpowering).

- 12 Once the picture is dry give the main group of objects a once-over with the burnt umber stick to make them just that bit more solid, and then vou can switch back to the gradual build-up of the pebbles. Where the beach fades off into the shoreline simply lay a base colour and then pick out some tiny highlights to suggest pebbles in the distance. All the highlights can be done together at the end, so for now use the side of your brown stick to block in a little colour and then lightly scribble over all the distant beach with a pale yellow. Then switch to a pale violet and scribble over the edge of the pale yellow and the drawn pebbles in front. You can then continue down the picture with this colour to add some highlights to the pebbles in the foreground, on the main body of objects and
- 13 In this close-up detail you can see how the pebbles have been built up with various dots and squiggles of colour. So long as you do not lay too much of any one colour which would destroy the balance – a remarkably detailed-looking effect can be easily achieved. Apart from the lightest highlights, you can now finish off the beach itself. Go over the area again, firstly adding yellow highlights, then brown lowlights and finally dark blue specks for the more distant pebbles. Then add some loose swirls of dark blue to suggest individual stones in the foreground.

on the piece of wood lying at

the front.

14 Your still life should now be really starting to come together. Use orange and pale violet to define the wooden planks on the large panels at

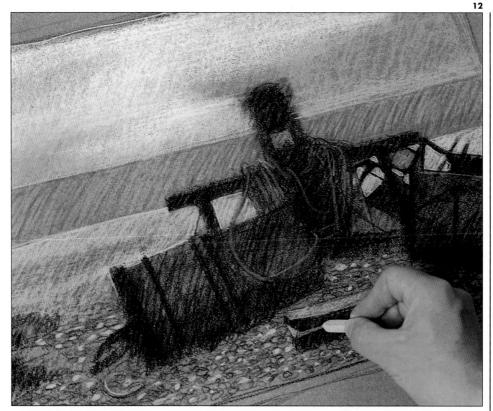

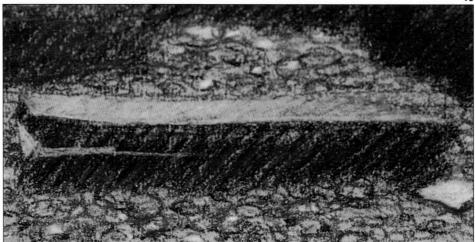

the front of the main group, softly smudging the colours together with your fingers. Next, use dark blue and brown to layer more depth into the shadowy areas - including the dark rocks to the left of the picture - again using your fingers to smudge and soften the colours.

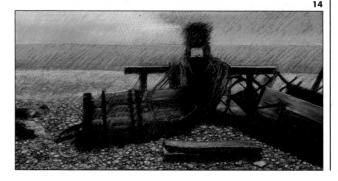

PASTEL/FLOTSAM AND JETSAM

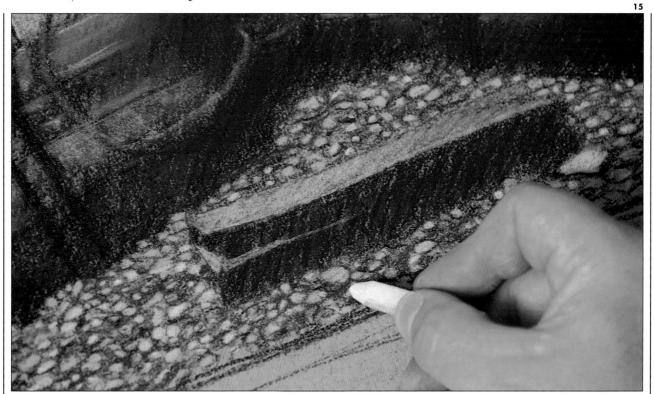

highlights can be added to the pebbles. Concentrate on the foreground first, using white, pale yellow and pale orange so that you get a complete range of hues. In addition, try to vary the size of the highlights to prevent them looking unnaturally uniform. One final note while on the subject of highlights: do not be tempted to use too much white as this will also appear harsh and unnatural.

16 For the distant beach the highlights are created with only tiny specks of colour – again the white, pale yellow and pale orange. Be sure to make your marks soft and gentle since only a suggestion is needed to create the illusion.

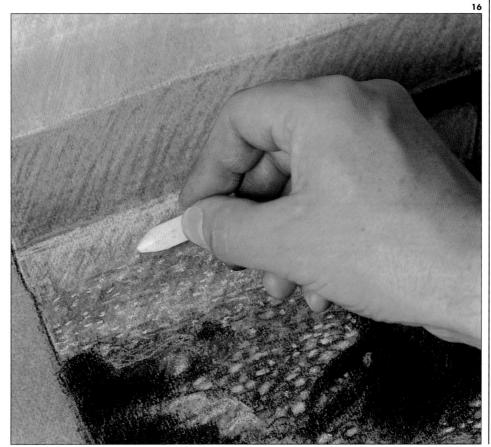

68

17 Use sky blue to 'cut in' (give a firm outline) around the top of the foreground group where it stands out against the sea, and then pale violet to mark in the very top of the group where it crosses into the sky. The last item to receive

attention is the coil of rope. Although this looks complicated, in fact it is simply a matter of going along the lengths adding grey dashes at regular intervals to suggest the form of spiralling twines in the rope.

18 A quick spray all over with fixative completes your picture. Now you can step back and view your work at leisure. Notice how the dashes to the rope (a very quick and simple exercise) make them look wonderfully detailed. The same

is true of the pebbles - which in reality are just a jumble of dots, specks and swirls in varying colours. Although this picture will have taken you quite a bit of time, it still has a great sense of being loose and spontaneous. This is a characteristic of work rendered in pastels, and part of its great beauty. So often people experiment with pastels and are disappointed to find that when they try working in details, the picture goes a bit 'flat'. Pastels are normally at their best when used in a very loose manner - and budding artists who want to produce very detailed pictures would probably be advised to avoid this medium – but as you will have seen from this step-bystep project it is possible to create the illusion of complexity when required, while still maintaining the true character of the pastel medium.

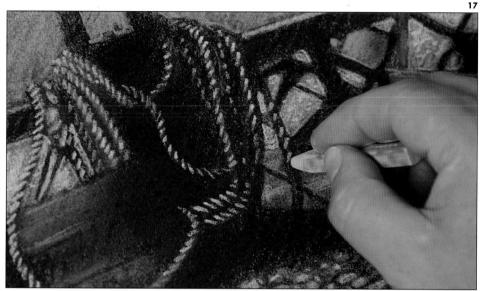

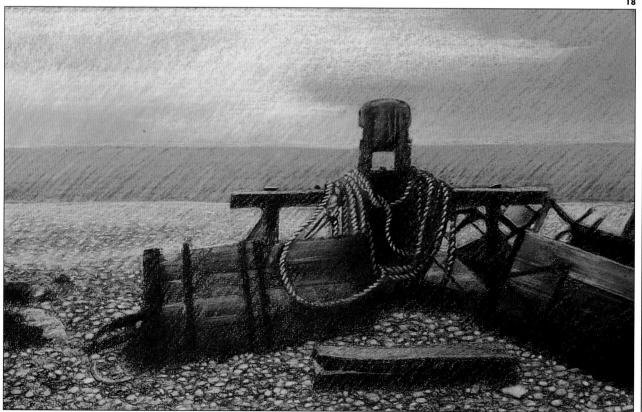

Chapter 5

Watercolour

In this chapter you are finally going to experience the thrill of using real paint. Although you will have gained some knowledge about working in colour from the previous chapter, it must be said that dry colour does not possess the versatility and range of effects that are possible when working with paints. In addition, 'wet' colours can be physically mixed together on the palette to create an infinite range of hues, whereas dry colours can only be mixed optically, on the paper.

The subtle translucency of pure watercolour makes it one of the most attractive of all the painting media. It can be a tricky one to master, however. You cannot paint light over dark or obliterate mistakes as you can with oils or

acrylics; and because the paint is so watery it can be difficult to predict what the finished effect will be. On the other hand this can be an advantage. If you take the time to master this medium, you will soon discover that its sheer unpredictability is all part of the fun.

In the second project we introduce gouache, which is an opaque version of watercolour. Although gouache does not have the translucency of pure watercolour it can still be watered down to create washes and in its neater form it is excellent for covering large areas with smooth, flat, opaque colour. It also has the advantage of allowing you to apply light colours over dark in a way that is not possible with pure watercolour.

Materials

WATERCOLOUR

Paints

There is evidence that a form of watercolour paint was used thousands of years ago by the Stone Age cave painters. The paints they used were made from ground pigments mixed with water and a binding medium such as starch or honey. Even today this process has hardly changed,

except that the pigment is combined with gum arabic and glycerin which produces an even wash of colour when diluted with water.

Pure watercolour comse in a variety of forms – tubes, pans, cakes, and bottles of concentrated liquid. The tubes and liquids are suitable for studio work and for covering larger areas of colour. Pans are blocks of solid, semi-moist colour which slot neatly into tailor-made boxes. These are ideal for working outdoors, as the lid of the box can be used as a palette. Tubes and pans are available in two grades, artists' and students', with the more expensive artists' quality containing more pigment.

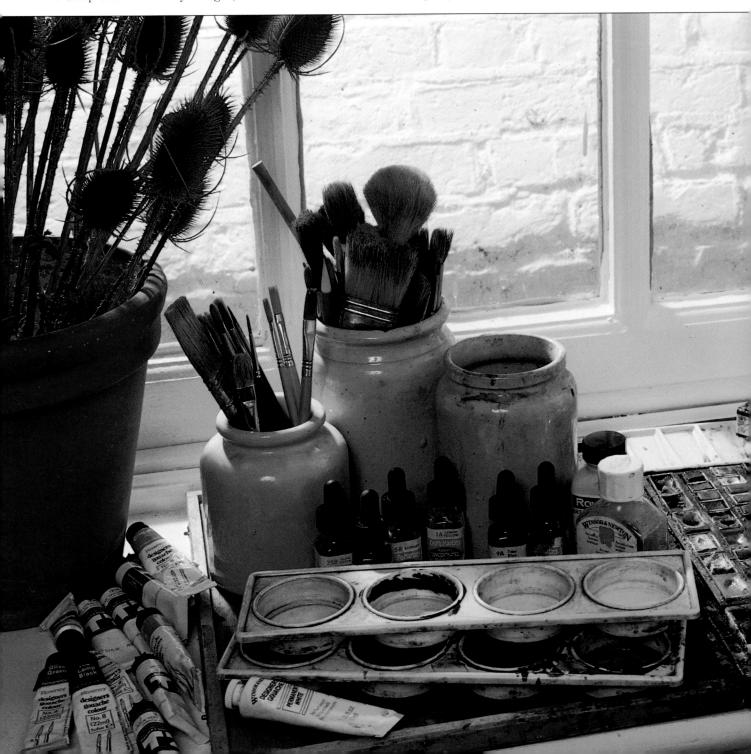

MATERIALS

Gouache contains the same ingredients as pure watercolour but is combined with chalk which gives its opaque quality. The colours are intense and brilliant, flow remarkably smoothly, and dry quickly. Gouache combines well with pure watercolours, and because it is opaque it is suitable for working on toned papers.

Supports

Watercolour paper is available in a variety of textures, weights and colours. Textures range from rough to semi-rough (cold-pressed) and smooth (hot-pressed) but the most popular choice is semi-rough. The weight (thickness) of watercolour paper ranges from 90lb (180gsm) to 300lb

(600gsm). The lighter papers tend to wrinkle when washes are applied and need to be stretched by soaking them in water then taping them to a board and leaving them to dry. Papers of 140lb or more do not require stretching. Pure watercolour is normally used on white paper, which adds brilliance to the transparent washes, but gouache works equally well on white or tinted papers.

Brushes

Depending on your budget, you can choose brushes made of sable, ox hair, squirrel - also known as camel hair as well as any of the synthetic types. Chinese hog hair brushes are versatile because they are capable of holding a lot of paint for laying washes but also taper to a fine point for painting details. However the purist will always recommend sable. These brushes are made from the hairs taken from the tail of the Siberian mink which is why they are so expensive. However, they are a good investment and will last a long time if well cared for. They are springy, resilient, and moulting hairs are never a problem as they can be with the cheaper brushes. You will need four or five brushes of different size – rounds for detail and flats for broad washes.

Other equipment

The only essential accessory for watercolour painting is a palette. These are available in ceramic, plastic and enamel. Some have rows of shallow cups and others have a row of small recesses at the back with larger mixing cups in front. They are convenient when using tubes of colour as you can squeeze the paint into the small cavity and mix it with water in the larger one when working with washes. On the other hand it is always possible to improvise with egg cups or saucers.

Techniques

PURE WATERCOLOUR

Laving a Flat Wash

One of the most important techniques when working in watercolour is that of laying a flat wash. The first step is to mix your chosen colour with plenty of water in a dish. making sure that you prepare a sufficient amount to completely cover the area that you are painting. Load a large brush with paint and lay it in long, even strokes horizontally across the paper, tilting the board towards you so that the colour pools at the bottom edge of each band and can be picked up with the next stroke. When you have covered the whole area, pick up any excess paint with a dry brush or small piece of tissue, before leaving it to dry. You must still keep the board in a tilted position to avoid the paint from flowing backwards which will cause the wash to dry unevenly.

Laying a Graded Wash

The technique of laying a graded wash is to start off with a darker tone at one end which gradually fades into a much paler tone at the other. To achieve this you must mix the colour with some water in a dish and keep a jar of clean water next to it. Load your brush with the paint mix and lay a long band of colour horizontally across the top of the paper, tilting the board towards you. Now dip the brush into the clean water and lay the next band underneath picking up the wet front created by the first band. Continue in this way until the whole area is covered to create a gradation of tone from top to bottom.

TECHNIQUES

Wet into Wet

Wet-into-wet describes the technique of laying one colour over another before the underlying wash has dried. This can create some interesting results as the second colour will bleed and merge into the first and enlarge the marks made by the brush.

Wet on Dry

This technique of waiting for the first colour to dry completely before laying another colour over the top will give you a very different effect to wet-into-wet. Here you can see how the edges of the second colour are clear and well defined.

GOUACHE

Wet into Wet

This technique is the same as for pure watercolour – painting one colour on top of another, before the first layer has dried – but because the paint is opaque you can make your second colour lighter. This can create some very exiting results – the marbling effect in this example being one of the most notable.

TECHNIQUES

Wet on Dry

Again this is the same technique of painting over another colour that has been left to dry. This example graphically shows the difference between pure watercolour and gouache, in the fact that you can paint white over a dark colour totally successfully. This enables you to work from dark to light, painting in the highlights at the very end rather than having to leave blank pieces of paper as you would with pure watercolour.

Aubergine Parmigiana

PURE WATERCOLOUR

One of the most traditional still-life themes is the culinary one, in which various foodstuffs and kitchenware are grouped together. This was a favourite theme of the 17thcentury Dutch painters, who seemed incapable of sitting down to a meal without painting it first. There are no lobsters or gold goblets in our project painting – instead we have a selection of ingredients for a simple Italian meal called 'aubergine parmigiana'. Although this selection was chosen for its interesting variety of tones and textures glass, metal, wood, shiny aubergines, papery-skinned onions and crumbly cheese – we have a sneaking suspicion that the choice was not purely an artistic one. Aubergine parmigiana just happens to be the artist's favourite meal and he got to cook and eat the ingredients when he had finished the painting. Worse still, we were not even invited to join him!

Composition is one of the most important elements in any still life, so the objects themselves need to be arranged with some care. The artist spent a great deal of time arranging the objects in this deceptively simple group so as to create a satisfying and harmonious composition. Although there are some basic guidelines to follow (explained in chapter 2) much depends on personal preferences and the effect you are trying to achieve, and it is unlikely that any two people would arrange this group in the same way. Having said that, there are identifiable reasons why this is a good composition. To begin with, the objects are grouped so that they overlap each other, which helps to link them together and also create a sense of depth and form. The composition is based on the shape of a right-angled triangle and this encourages the viewer's eye to move around the group. The angle of the kitchen knife leads the eye from right to left, directly across to the aubergines, the angles of which take the eye up towards the top of the olive oil bottle. From there, the yellow highlight on the side of the bottle leads the eye back once more to the kitchen knife. Notice also how the background is divided into three panels of different tone, giving it visual interest while not distracting from the group itself.

On a more technical note, you will see how, if you compare this to the finished painting on page 83, that certain details have been altered. Slight repositioning of the objects has been used to make the composition even tighter, but the most obvious change is the shape of the table top. The only table available was round, but the curved line at the back would have been difficult to capture accurately and would have distracted the viewer from the main composition.

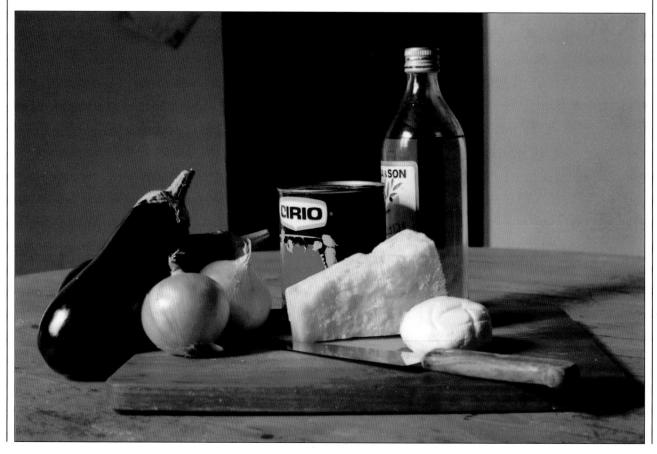

1 The first stage is to make a light outline drawing of the subject so that you can check your composition and plan the order of painting. With transparent watercolour be careful not to make these lines too strong as they will show through the paint. Sketch the outlines lightly with an HB pencil or, as here, a light-coloured pastel.

2 Mix up a wash of yellow ochre mixed, alizarin crimson and burnt sienna. Dilute this to a pale tint and, with a large wash brush, apply it over the whole picture except for those area which are to be left white – the highlights on the aubergine, the onion, the knife and the bottle, the labels on the jar and bottle, and the lump of mozzarella. This first wash will give you a base colour to work up from.

The main areas of tone can now be quickly added. Starting from the top, lay a wash of sepia over the entire background and the edge of the board, then darken the colour with burnt sienna and paint in the dark area on the side of the bottle. A very weak mix of cadmium yellow can then be washed over the wedge of parmesan cheese and dabbed with crumpled tissue to remove any excess of paint. Use the same colour, but in a stronger dilution, for the narrow highlight running down the edge of the bottle. Finally, paint the table top with a pale wash of yellow ochre.

3 A gentle wash of burnt sienna can now be applied over parts of the background to achieve distinct areas of dark and light. This will not only add interest, but more importantly give your picture depth. Switching to the objects in the group, using cadmium red for the tomato and Hooker's green with a touch of cadmium yellow for the foliage, pick out the details on the labels of the tin and the olive oil bottle. Then lay

cadmium yellow over the shadow area of the cheese and quickly blot it with tissue to create a mottled effect resembling the crumbly texture of the cheese. Also use the yellow to add a pale wash over the olive oil bottle, except for those parts which are to be left white.

PURE WATERCOLOUR / AUBERGINE PARMIGIANA

- Mix a thin wash of vellow ochre and burnt sienna and apply this all over the background. When this wash has dried add further washes, sometimes to the whole background and other times to small sections, to create tonal variations in the background panels. Each wash adjusts the colour slightly, and you can continue this process until you are happy with the result. Use the same colour to deepen the tones of the table top and chopping board.
- 5 When the background washes are completely dry, return once more to the still-life group. Mix Prussian blue with a small amount of sepia and paint the black area of the tin's label (avoid using neat black as this colour tends to go 'dead'). Apply a wash of burnt sienna to the chopping board, darkening the tone in the shadow areas.
- Continue building up the warm, golden-yellow tones of the olive oil in the bottle with washes of burnt sienna mixed with yellow ochre; leave the brightest highlights, on the outer edges of the bottle, untouched. Notice how these simple 'blocks' of light. medium and dark tone effectively convey the effect of light shining through the liquid, and how the areas of white paper you left for the highlights on the glass are already starting to stand out. Moving to the lump of cheese, add more cadmium yellow, and once more dab it with tissue afterwards. By repeating this process a great depth of texture will be achieved.

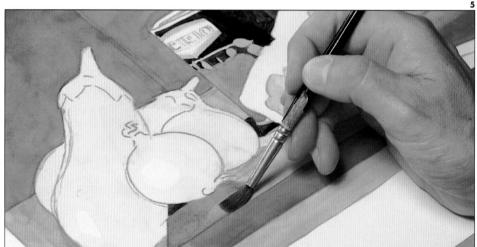

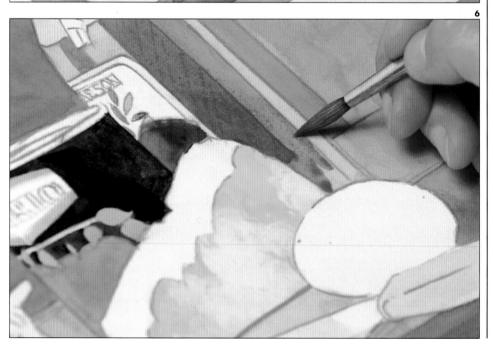

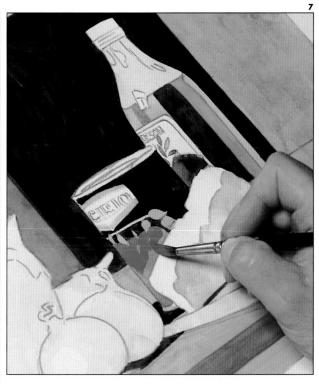

The beauty of painting a still life in watercolour is that while one area is drying you can work on another. In this way the whole picture progresses at once, and you soon get a feel for what the finished result will look like. Now that most of the basic tones are established you can work in quick succession around the picture. Start by adding a heavy sepia wash to the central panel of the background. By the time you have finished this, the bottle should have dried, allowing you to darken the central band of shadow with the same heavy sepia. Then use cadmium red to brighten up the tomatoes on the tin's label.

Continuing with your rapid 'journey' around the painting, go over the wedge of cheese once more with cadmium yellow and dab it with tissue to further build up its tone and texture. Then paint the aubergines with a dark mixture of maroon, sepia and a little crimson. To convey the roundness of their forms, lighten the tone along the upper edges by adding more water to the paint and darken towards the bottom. Switch back to the bottle once more and add another layer of burnt sienna and vellow ochre over the darks and mid tones. Use very watered down black to suggest the shadows on the lump of mozzarella. As you can see, by attending to these few areas you have rapidly changed the whole picture.

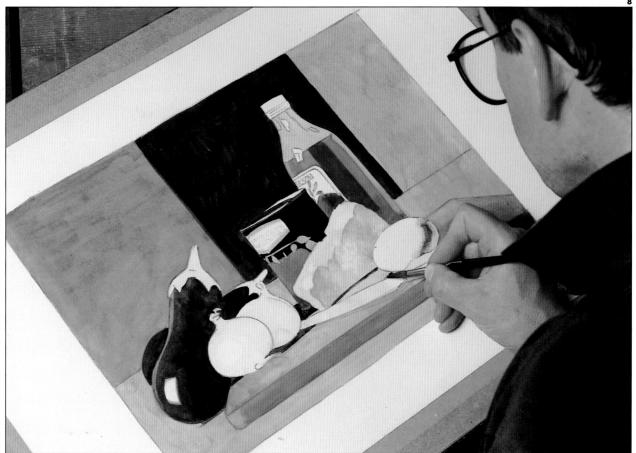

PURE WATERCOLOUR / AUBERGINE PARMIGIANA

Now you can begin to add the textural details that will bring the whole picture together. To imitate the grain of the wood on the chopping board, mix burnt sienna with vellow ochre and very little water. Use the tip of a very fine brush to paint thin, slightly wavering lines along the board. The trick is to ignore your reference, but to paint these lines quite randomly; if you paint them too carefully, trying to follow the true texture, you can easily ruin the effect and overwork your painting.

10 If you look back to the picture in step 8 you will see that the dark panel behind the bottle has dried unevenly – a problem that sometimes occurs in watercolour. So here is a

handy tip if ever you need to smooth out an uneven area of flat colour that has already dried. With a clean brush lay water over the whole area and then 'drop in' some neat pigment at regular intervals. The water will lift the existing pigment and the colour dropped in will spread out through the water and merge with the existing pigment. Leave the painting to dry undisturbed, and the result will be a much smoother area of colour - as you can see in this photograph.

The next stage is to paint the top part of the bottle which, because it contains no liquid, reflects the dark colour of the background panel behind it. Since the panel was painted in sepia, this colour is also used for the bottle, but this time in much lighter tones. Working carefully around the highlights, start with the lightest tones and work up to the darkest, creating shapes which follow the curve of the bottle.

The aubergines and onions can now be tackled. Paint the tops of the aubergines with a mix of Hooker's green and yellow ochre, allow to dry and then model the shadowed parts with sepia. Block in the onions with a pale wash of burnt sienna and yellow ochre, leaving white areas of paper for the highlights. While the paint is still wet paint the shadows with deeper tones of the same colour, using curving brushstrokes that follow the rounded forms of the onions. The various tones will merge to create a smooth, naturallooking contour.

12 The bottle can now be finished off by painting the cap. Mix up some yellow ochre with a very small amount of sepia and use this to paint in

the outline areas of the bottle's cap. Allow to dry. Then darken your mix with more sepia and use a very fine brush to add the tiny ridges and indents.

13 A couple of finishing touches and your painting will be complete. Use a very fine brush and a mixture of burnt sienna and yellow ochre to suggest the wood grain on the table top and on the handle of the kitchen knife. Then use various mixtures of yellow ochre and sepia to paint the shadows and reflections on the blade of the knife.

At last it is time to step back and admire your work. As you will have discovered, this was a deceptively easy painting to do. Although the finished result looks impressive, most of the picture is in fact made up of areas of flat colour. Even where blending of tone was required, for instance in modelling the form of the onions and the top of the bottle, these were limited

to one predominant colour and no particular form had to be followed. Simple 'tricks', such as blotting the wet paint to suggest the crumbly texture of the cheese, have contributed some lively touches.

The real lesson to be learnt from this project is the importance of planning your subject carefully before you start to paint. Take the time to study your still-life group, moving things around if necessary in order to create a more interesting composition. Then decide how you are going to approach the actual painting; this is particularly important in watercolour because mistakes cannot easily be rectified. However daunting the subject, if you keep your head you will be amazed at what you can do.

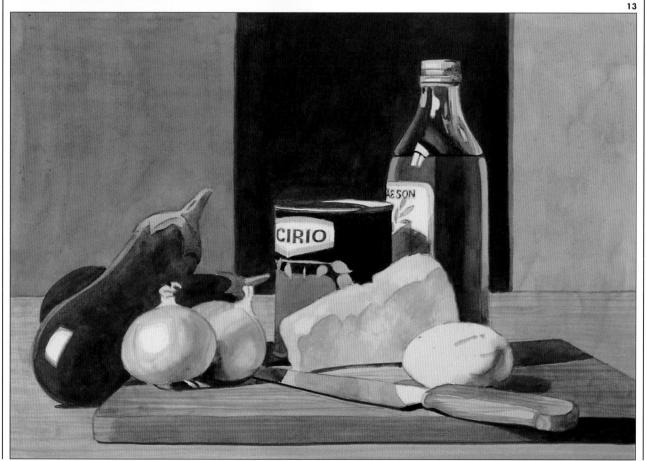

Daisies on Kilim

GOUACHE

A vase of flowers is considered a classic still life subject, so we felt that we should include one in this book. However, we did think that on its own this would have been a little too easy. As we like to make the projects a bit of a challenge we decided to turn a simple image into a more complex composition by adding the patterned kilim as a background. We are not suggesting that an isolated vase of flowers cannot hold its own and create a stunning image, it's just that we like to make your lives difficult!

The other interesting thing about this composition is that, whereas normally the brightest colours would be in

the flowers, here we have chosen fairly plain blooms and accentuated the background colours.

Hopefully this project also shows you how versatile gouache can be as a medium. Diluted with water it is capable of producing subtle washes, but when used in a neater state it becomes opaque, lending itself to solid blocks of colour, as in the kilim. Of course you are not obliged to follow any of the projects rigidly and if you do not feel ready to tackle the kilim just paint the flowers with a plain background and add the kilim when you feel more familiar with gouache and have gained some confidence.

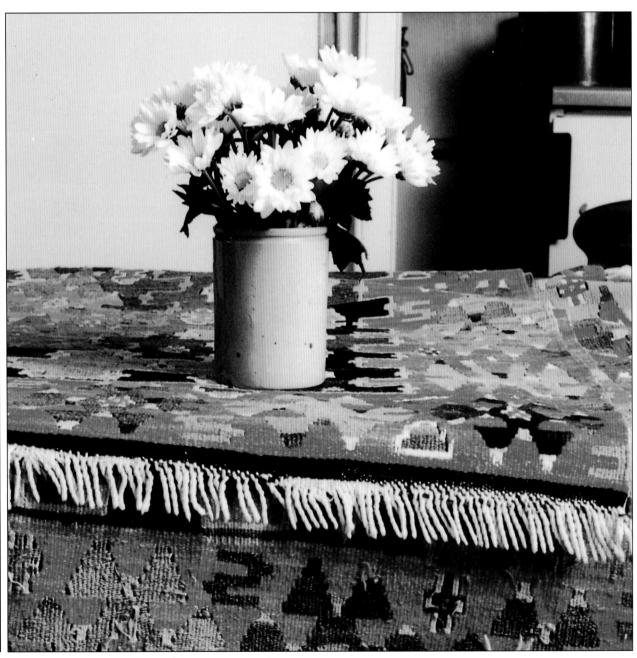

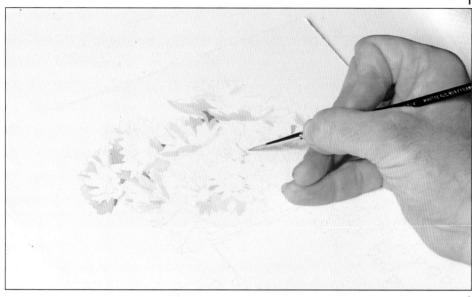

Start with a detailed outline drawing in pencil. Your support is a white watercolour board, so you should use a fairly soft-leaded pencil that will not damage the surface. You need not worry about your pencil drawing being too dark, as gouache is an opaque medium and therefore the lines will not show through your finished painting. This is lucky as you will need to render the pattern of the kilim quite precisely. With a mix of white, yellow ochre and a little cobalt blue, start to paint in the darker grey/greens of the shadows on the flower heads.

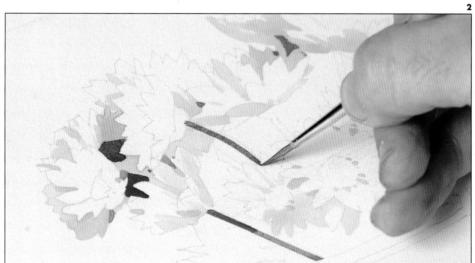

2 You will notice that the flowers contain subtle variations of tone. To achieve this it is all a matter of how much water you add to the pigments: to create the paler tones you add more water and for the darker tones you use less. With a mix of permanent light green and cobalt blue, darkened with raw umber, begin to paint the stems and cut in around the flowers to give shape and form to the various petals.

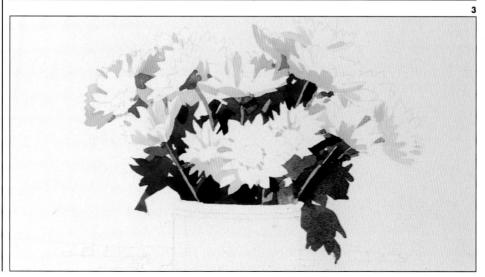

3 Darken your mix with a little more cobalt blue and raw umber and paint the darkest leaves, again varying the tones with the addition of water. Because gouache is an opaque medium, people tend to think it must always be used thickly. But the fact is that with the addition of enough water, gouache will behave just like pure watercolour and can, therefore, be built up in layers.

GOUACHE / DAISIES ON KILIM

With a new mix of white, cobalt blue and ivory black, again with quite a bit of water, add in the background on the left-hand side. Break this up with patches of dark, to avoid a solid, flat feel, and carefully cut in around the petals. Using pure golden yellow and a little water, paint the centres of the daisies, adding a little white to the colour for the lighter parts. This is one of the advantages of working in gouache. Due to its opacity, lighter shades may be painted over dark colours.

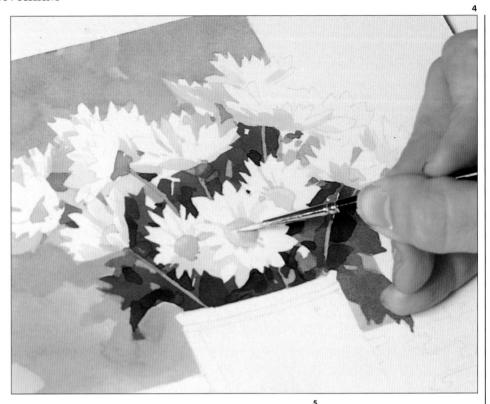

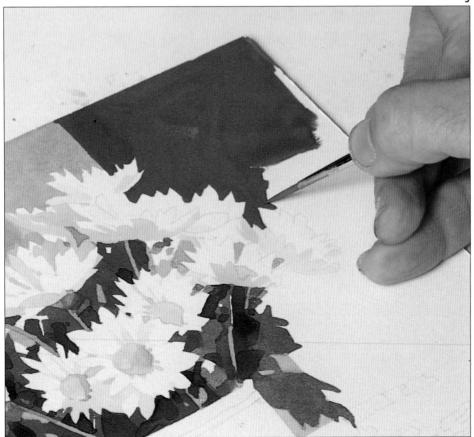

Darken your background mix further with a little more cobalt blue and ivory black. You are now going to paint in the right-hand side of the background. It is often a good idea to split a background in this way, since it not only adds interest, but plays tricks with the viewer's eye. The dark side of the background pulls the eye across the painting, but then it is pulled back by the bright vellow centres of the flowers. This way the viewer misses nothing and is able to absorb the painting as a whole.

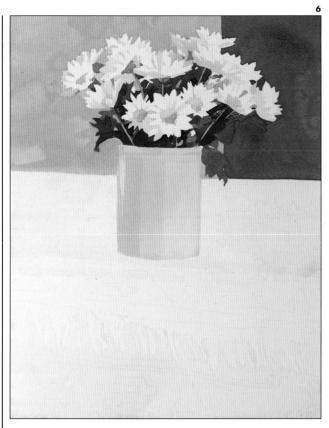

6 With a mix of yellow ochre, ivory black and lots of water, paint over the vase and the whole of the kilim except for the tassels. Adding a little white to the mix to make it more opaque, and this time using much less water, paint the shadows on the vase. Notice how the shadow tones gradually darken towards the edges of the vase, accentuating its rounded form; add a little cobalt blue to the mix when painting the darkest shadows.

Now leave the painting to dry. Although you may hurry it along with a hairdryer, it is usually best – if you have the time – to allow it to dry naturally. This not only allows you to take a break, but the watermarks will appear more natural and, to quote the artist, really make the painting 'sing'.

7 In the same way as you used your white support for the flowers – by painting around them and then cutting in to create their shape – you are now going to 'create' the tassels. Using the same mix, start to cut in around the shapes of the tassels. Continue below the tassels in downward strokes. This will establish a background for the kilim.

You are now going to embark on the most difficult part of your painting – the pattern on the kilim itself. Start with the easiest part – mix some lamp black with water and fill in the dark pattern to the right of the vase, the line along the edge of the table, and the darker shadows between the tassels. With a new mix of permanent light green, black, yellow ochre and white, start to paint in the greens of the kilim. Paint the blue parts with a mix of cobalt blue and ivory black and the red parts with a mix of crimson and yellow ochre. The colours can be tackled in any order you like.

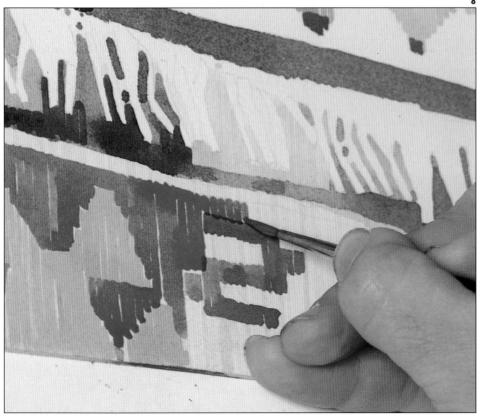

GOUACHE / DAISIES ON KILIM

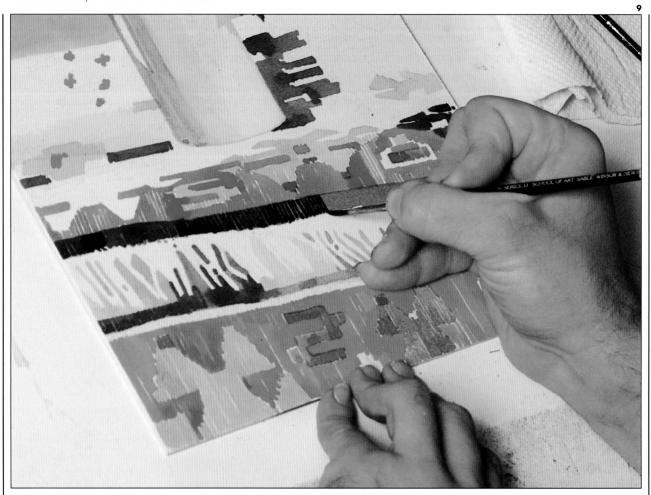

- 9 Keep all of these colour mixes separate, so that you can return to them as you gradually build up the pattern of the kilim. Remember to vary the tones of your colours by using more or less water. To imitate the heavy weave of the kilim, fill in each colour area with a series of vertical strokes, leaving tiny spaces between them. Using this technique, strengthen the black edging on the kilim with lamp black, used almost neat.
- 10 Once you are happy and have filled in all of the kilim, leave the painting to dry. Then add a little titanium white to each of the individual colours to create the lighter shades and go back over the kilim to

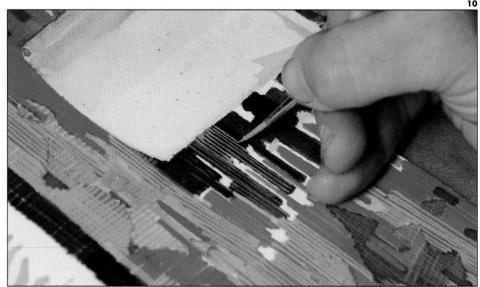

emphasize the weave even further. Now that your painting is complete you will notice how the weave of the kilim creates an interesting contrast to the flat background.

11 Although you may have found these last stages rather time-consuming and laborious, you can now stand back and admire the fruits of your labour. You will also see why a

pale overall wash was laid over the kilim before you started. Even though your white support has been used to its full potential, for example in the flowers and the tassels,

pure white would have created too harsh a contrast with the colours in the areas that have been left 'bare' in the kilim. As well as an exercise in patience, this project will have shown

you the versatility and pleasure of working in gouache as an excellent alternative to transparent watercolour.

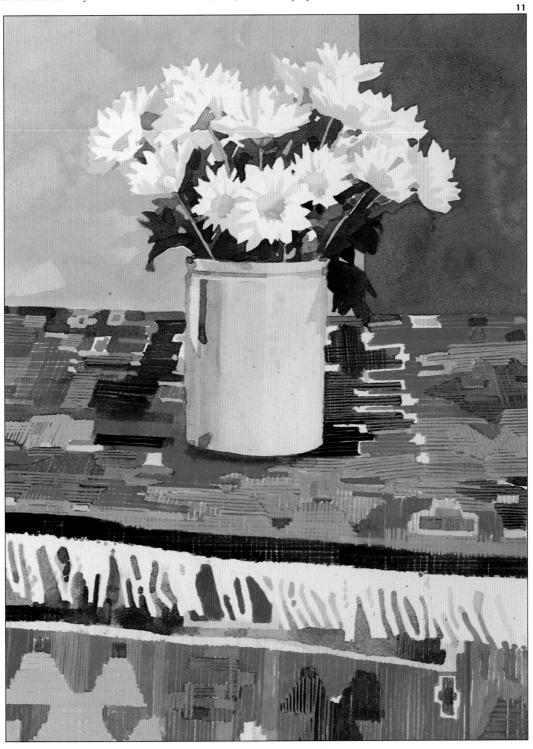

Chapter 6 Acrylics

In this chapter we explore a fairly new and modern medium, acrylics. Synthetically made acrylic paints were developed in the 1920s and were intended for industrial use. However, due to their weather resistance and fast-drying qualities, artists working in Mexico began to use them to paint huge murals. With the advent of a radical new style of painting in the 1950s and '60s, acrylics came into their own. This new movement, known as 'Pop Art', called for bold, bright colours to suit its brash personality. The 'Pop' artist depicted the modern environment by using images from American popular culture – everything from soup cans to hamburgers. It was an experimental period, and discovering the creative

potential of a truly modern paint medium added to the excitement. When the likes of Warhol, Hockney and Lichtenstein gave it their seal of approval, acrylics were finally accepted.

Since this time artists have discovered that acrylics can be far more subtle than originally thought. In this chapter we present you with two still life paintings designed to demonstrate just how versatile acrylics can be. Having said this, we are always keen to encourage you to do your own thing. So if you are feeling bold and decide that you want to take acrylic back to its roots, there is nothing stopping you from creating your own mural and brightening up that rather boring outside wall.

Materials

ACRYLICS

Paints

Acrylic paints consist of pigment suspended in an acrylic resin, hence their name. It is this synthetic resin which makes acrylic the most durable and permanent form of artists' paint. In fact acrylics are even weather-resistant which means they can be used to paint outdoor murals. It is interesting that the majority of restoration work carried out on oil paintings today is done with acrylics, for they never discolour with age and are so flexible that you can roll up a

painted canvas even after many years, and it will not crack. Acrylics are also very versatile and when thinned with water will produce translucent washes similar to those of watercolour. Artists' grade acrylic colours are brilliant, non-yellowing and – unlike oils – very fast-drying. Vinyl and PVA colours are similar to acrylics but cheaper. They contain inferior pigments and are therefore not so permanent but they are still popular with mural painters as they are available in large tins.

Painting Mediums

There are several types of acrylic painting medium that can be added to the paint to alter its consistency and produce different effects. Gloss medium makes the paint more fluid and transparent and gives the colours a soft sheen when dry. Matt medium serves the same purpose, but dries to a matt finish. Gel medium is used to thicken the paint to make it suitable for textured effects. Retarder is a translucent gel which slows down the drying time of the paint.

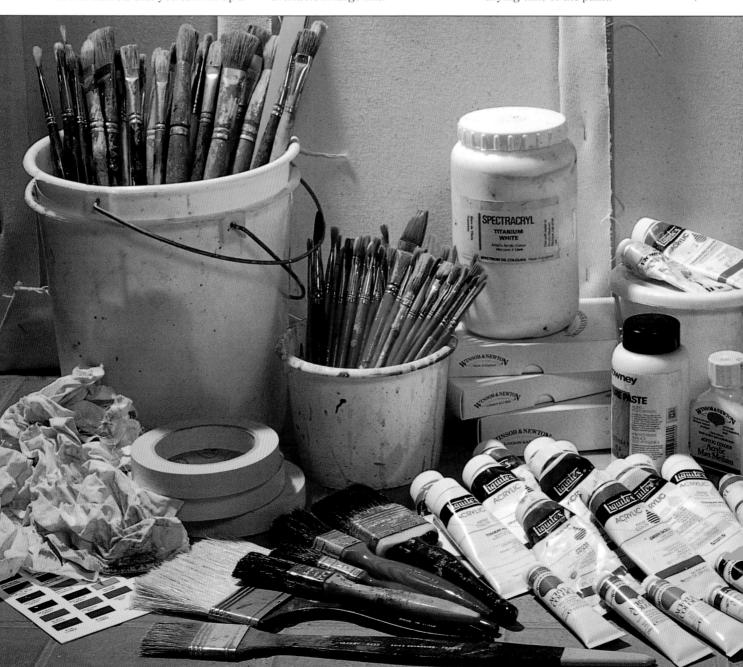

Supports

Although it is said that acrylic paint can be applied to any surface, it cannot be used on a support that has been prepared for oil paint or which contains wax or oil of any description. This is because the paint will not adhere properly and will eventually peel off. The most popular supports are canvas, hardboard and paper (which must be thick enough to hold the weight of the paint). Apart from this, wood, metal, fabrics, plaster and even concrete are all suitable, as long

as they are first primed with acrylic gesso or household emulsion.

Brushes

Brushes used for oil and watercolour painting are also suitable for acrylic painting (though if you are using brushes which have been used for oil painting they must be thoroughly cleaned to remove all traces of oil from the bristles). Some artists prefer to use nylon brushes instead of bristle or sable as they are stronger and also easier to clean. Decorators' brushes

MATERIALS

are cheap and are useful for blocking in large areas of colour. Acrylic paint tends to dry on the tip of the brush, so always keep your brushes in a jar of water during a painting session and clean them thoroughly afterwards.

Palettes

A palette made of white plastic or ceramic will enable you to clean off the paint even when it has dried hard. A wooden palette is not recommended as the paint becomes ingrained in the wood and is impossible to remove.

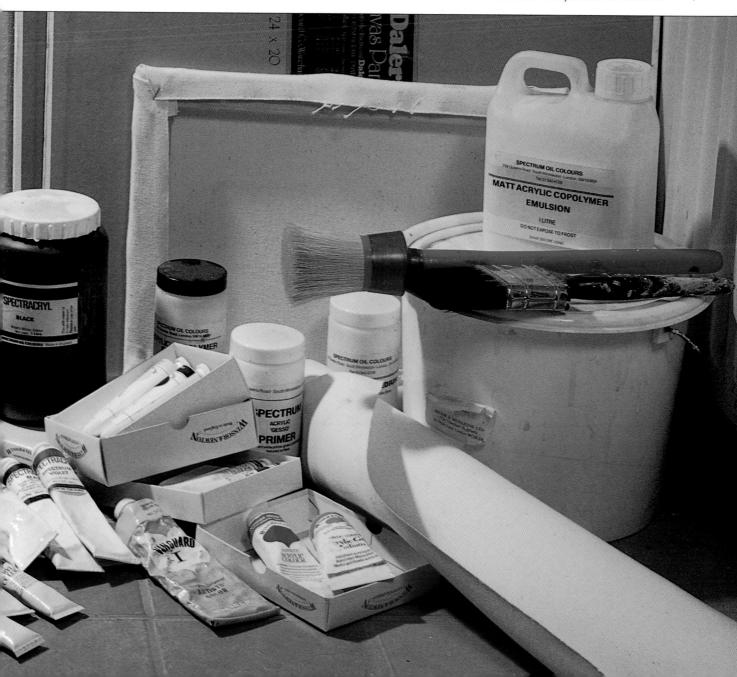

Techniques

ACRYLICS

The following three examples are not actually techniques, but they illustrate the various effects that brushes of differing sizes will make on the support.

Round no. 8

A small round brush is essential for painting fine strokes and details. The actual size you require will depend on the scale of your work and your own personal preferences.

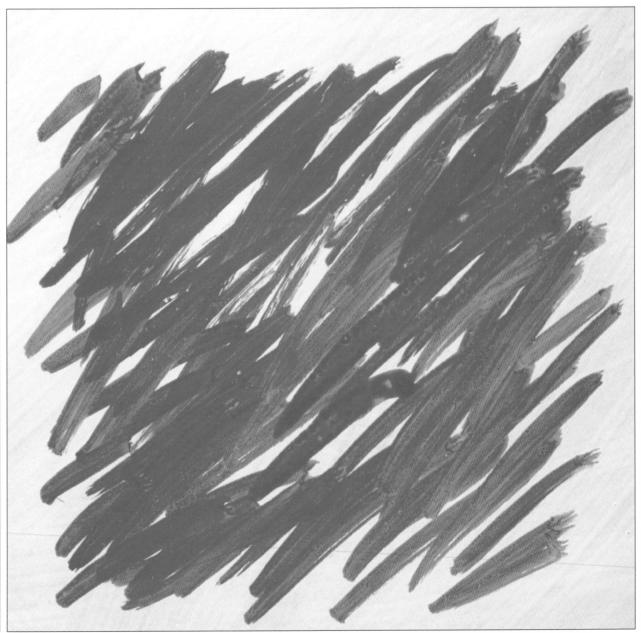

TECHNIQUES

3/8 in (1cm) flat softhair brush The long bristles of this brush make it sensitive to pressure, allowing you to

easily alter the brush mark.

1½ in (3.8cm) decorator's brush This brush is extremely useful for filling in extensive areas of colour in the initial stages of a large painting.

ACRYLICS

Thick over Thin

This technique really shows how versatile acrylics can be. Thin down your chosen colour with lots of water and lay a wash. When this has dried, and with the same paint but undiluted, lay another layer over the top. This will completely cover the initial wash without a trace of it showing through. As you will see in the two step-by-step projects which follow this allows you to lay an initial underpainting from which you can gradually build up your painting.

Thin over Thick

Although this technique is not used very often, it certainly creates some interesting effects. Start by painting a thick layer of paint onto your support and allow it to dry. Dilute another colour with lots of water and paint this over the top. You can see that this allows the underlying colour to show through.

TECHNIQUES

Blending

Acrylics dry quickly so subtle graduations and blendings of colour are quite difficult to achieve. However, the addition of gel medium to the paint gives it a consistency nearer to oil paint and prolongs the drying time.

Another alternative, shown here, is to rough-blend using short, dense strokes. Working quickly, before the paint dries, apply the two colours next to each other and 'knit' them together by stroking and dabbing with your brush at the point where they meet.

Lobster

ACRYLICS

The artist chose this particular composition because it contains interesting contrasts of texture and colour, and because the lobster is a classic subject for still life painting. At least that was his reasoning, though there was an added incentive in that, lobster is one of his favourite foods and he got to eat it after the painting was completed!

Another aim of this project is to show you how versatile acrylics can be. Not only can they be applied thickly, like oils, but when diluted with enough water they allow you to build up forms with delicate, transparent layers of colour – a technique which is used to great effect when painting the lobster. Acrylics are also perfect for rendering the rich, bold colours of the lobster.

For this project the artist has chosen as his support the smooth, upper side of a sheet of hardboard. This nonabsorbent surface allows him to apply wet washes and push them around with the brush to suggest the rough, pitted surface of the lobster's shell. Instead of sinking into the support, as it would with canvas, the paint 'sits' on the surface until it dries, leaving the brushmarks intact.

Seafood conjures up images of the Mediterranean, so the supporting elements – a simple plate, blue-and-white checked tablecloth and terracotta floor tiles – were chosen to reinforce the theme as well as providing textural contrast. Having arranged your still-life group, it is always worth studying it from different angles and viewpoints to see which creates the most interesting composition. In this case, a straightforward side-on view would have meant that all the beautiful detail and markings which run along the back of the lobster would have become insignificant. And the tiles, cloth and plate would have presented a perspective problem! To overcome this, the artist decided to stand on a chair and photograph the group from directly overhead, and then work from the photograph. This way he not only managed to get everything into his picture but he also created an eye-catching composition containing some interesting shadows.

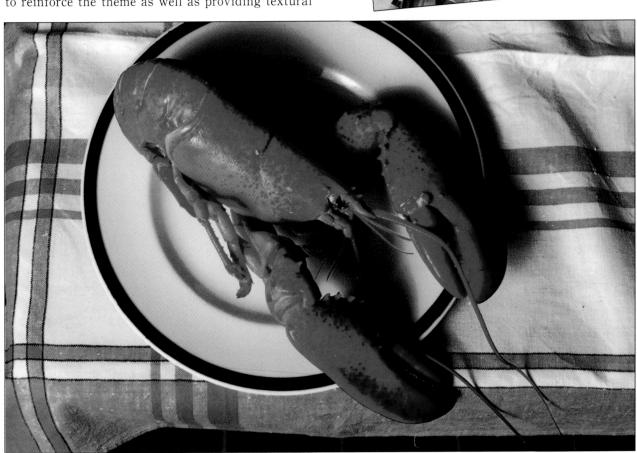

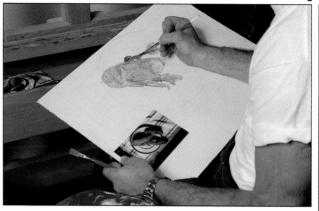

1 To create a white surface on which to work, the hardboard support must first be primed as you would a canvas. For this use acrylic gesso primer or, a cheaper alternative, a 50-50 mixture of ordinary household emulsion paint and emulsion glaze (available from art shops). Using a large decorator's brush, apply three or four thin coats of primer, allowing each coat to dry thoroughly. When the board is ready use a graphite.pencil to make a fairly detailed outline of the subject. To paint the lobster you will need cadmium red and yellow, raw umber and Payne's grey and a 1/4 in (7mm) flat brush.

3 Work up to the darker tones, using a more reddish mixture for the pincers. Here you can see how watery the paint is; the smooth surface of the board 'resists' the washes, which stay wet long enough for you to push them around with your brush to suggest the form and texture of the lobster's shell.

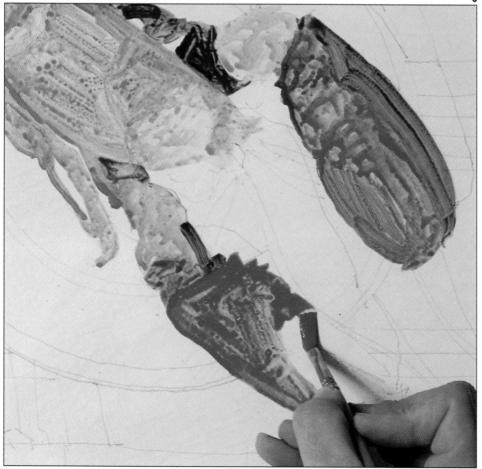

ACRYLICS / LOBSTER

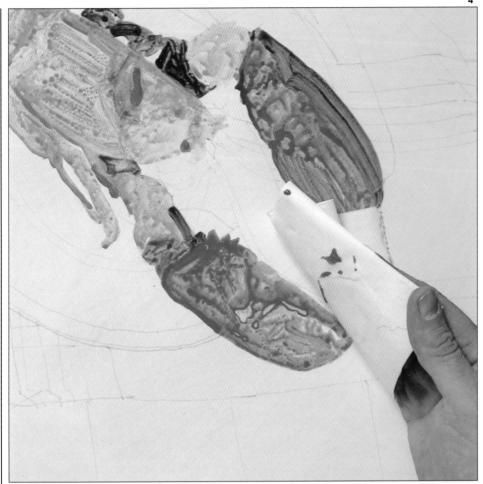

- 4 Having put down your first layer of paint and completed the shape of the lobster, allow the paint to dry thoroughly before adding further layers. This can be speeded up by using a hairdryer but not on a high speed, as this would blow the paint around. Alternatively, blot the wet areas with kitchen roll, which in fact will add even more to the textural effect.
- Switching to a small round brush, continue to work on the lobster, building up definition where needed. Use the paint slightly thicker now, and with more precise strokes, but allow the watermarks created on the hardboard with your first wash to show through. As you can see from this picture the main shell and pincers have, almost by accident, taken on textures that would have been very difficult to achieve if you had been trying for them. With the small round brush and a dark, reddish mixture, paint the feelers and the eye.

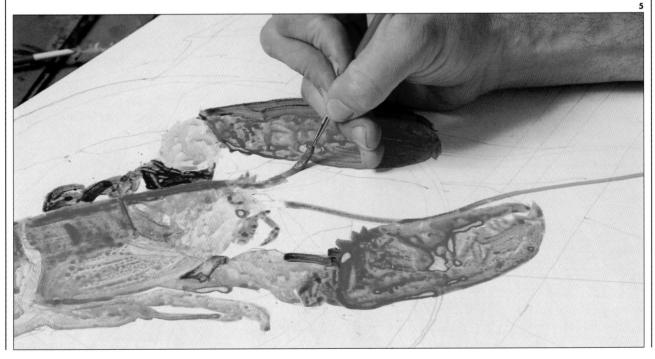

- 6 The advantage of working with a limited palette is that you can easily vary the tones and intensities of your colours, but still maintain an overall sense of unity. Here you can see that the artist has not added to his original four colours, but mixed them additively to create a range of tones from dark to light.
- 7 With your 1/4 in (7mm) flat brush, darken the pincers once more to give them a more solid appearance. You will notice on the original reference photograph that the lobster's

shell is dotted with random dark spots. To avoid the tedious and time-consuming job of painting these in individually, which could well end up looking unnatural anyway, here is a short cut - atechnique known as spattering (explained in more detail on page 120). Load some paint onto the brush – but not so much that it is dripping - and tap the handle of the brush, as if you were flicking the ash off the end of a cigarette. This will send a tiny shower of droplets onto the paint surface and voilá! - the job is done.

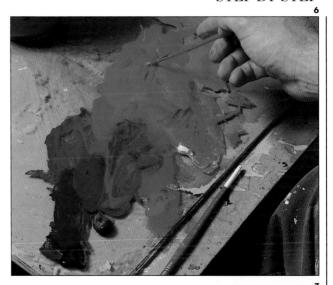

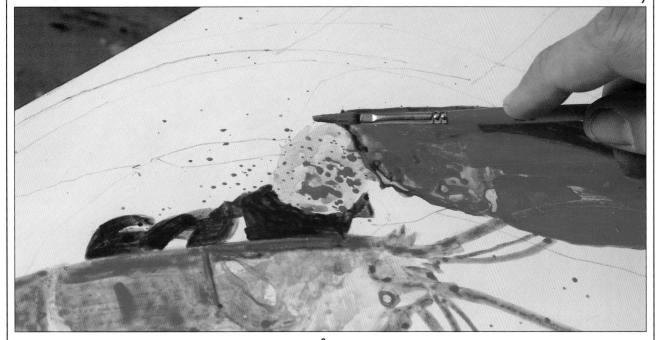

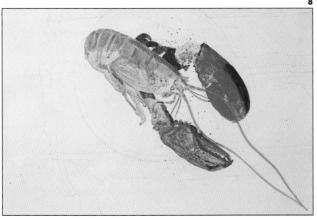

8 At this point it is a good idea to step back and take an overall view of your painting. Overpainting and working on unnecessary details is not only time consuming but also tiring, so instead of hurrying the drying process along we suggest that you take a coffeebreak, as the artist did here! As you can see, the lobster is looking almost finished.

ACRYLICS / LOBSTER

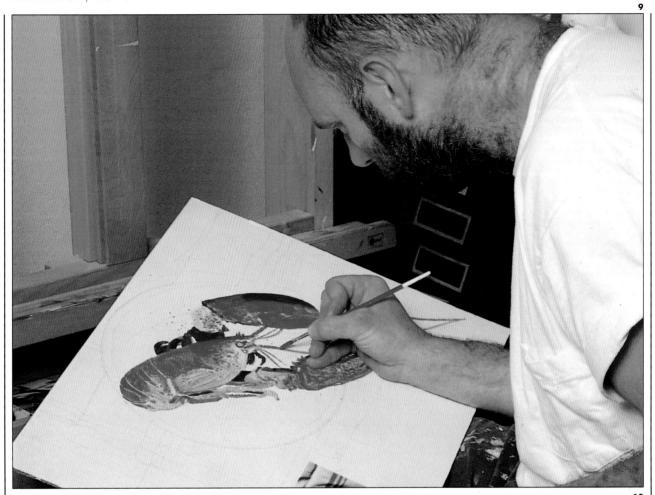

Never be afraid that if you take a break from the painting you will lose momentum. Far from it, for when you do return to your painting you will be able to look at it in a more detached way, which is a great help when you are working so closely with an image. Although the lobster is looking good so far, there is still more work to be done. Returning to your 1/4 in (7mm) flat brush and with a thicker paint mixture, darken the top of the main shell. Use the very tip of the brush to depict the tiny ridges running all the way along the feelers.

10 Now that the lobster is almost complete it is time to start work on the plate. Moving on to other elements in the painting enables you to get a better feel for the image as a whole and allows you to judge the contrasts of tone and colour between the various parts of the composition. If you have been struggling to work with the painting on your knees, you can now put it on an easel as you will be using thicker paint here. With an 1/8 in (4mm) flat brush and a fresh mix of monestial blue and Payne's grey, paint the dark blue stripe around the edge of the plate. Carefully follow your pencil marks, and use long, firm strokes to achieve a continuous, curved line.

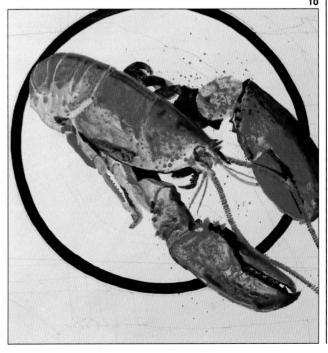

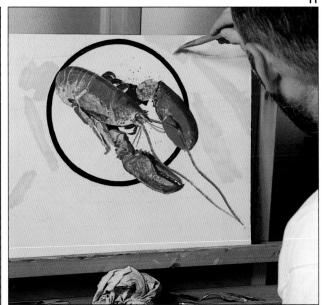

11 Your next task is the tablecloth. This is where you will realize the value of a detailed initial drawing, as it is vital to get the folds of the tablecloth in the right places. With a thin mix of titanium white, ivory black, cerulean blue and yellow ochre and a ¹/₂ in (13mm) flat brush, follow your pencil lines and block in where the folds and shadows appear. Allow to dry, then dilute the mixture with plenty of water and paint in the rest of the tablecloth. Your mix should be thin enough not to block out the pencil lines indicating the blue checked pattern of the tablecloth.

12 Add a touch more yellow ochre to your shadow mixture. Using the pigment more thickly now, paint the cast shadows on and beneath the plate, which have a slight greenish tinge. Use a ¹/4 in (7mm) flat brush, switching to an ¹/8 in (4mm) flat brush for the fiddly areas around the lobster.

STEP BY STEP

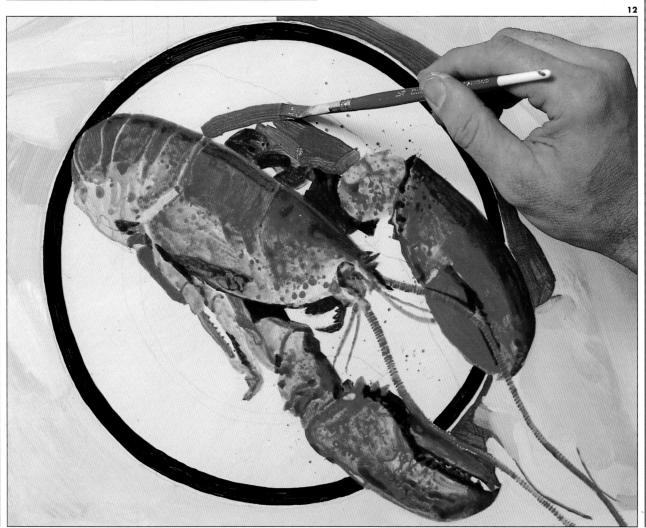

ACRYLICS / LOBSTER

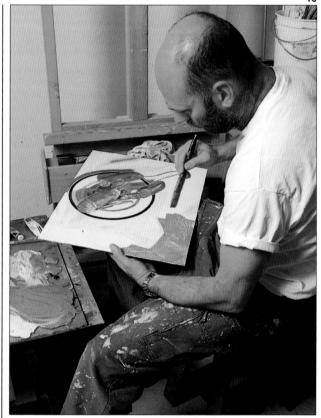

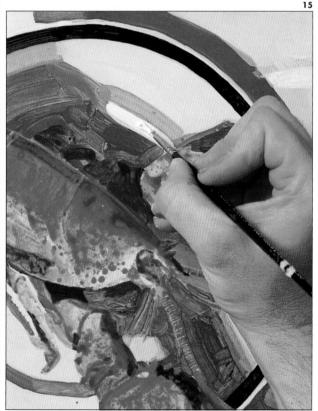

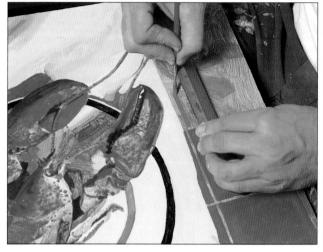

13 The lobster has cast a slightly pink tinge onto the shadow created by the inner rim of the plate – to catch this. add a small amount of cadmium red to your mix to complete the circle. Now here's is a nice easy bit! Instead of laboriously painting the lines of grouting between the tiles, the idea is to lay a wash of grey over the whole of the floor area, leave it to dry, then paint the tiles over it, leaving narrow lines of grey between them (see step 16). Using a 1 in (2.5cm) flat decorator's brush and a fairly thin mixture of yellow ochre and Payne's grey, paint in the area around the tablecloth. Keep the paint fairly thin so as to avoid obliterating the pencil guidelines for the floor tiles. The artist has chosen to do this section with the board laid flat on his knees. since this makes it easier to cut into the outline of the cloth. Leave the paint to dry.

14 Back to the easel now, as you have some precise work to do on the floor tiles. The mix for the tiles is cadmium red, yellow ochre and raw umber, mixed with very little water; the colour must be dense enough to cover the grey undercolour. To achieve the

perfectly straight edges of the tiles, use a technique called brush ruling. Hold a ruler firmly against the painting surface, bunching your fingers underneath it so that the edge is not touching the surface. To make the line, place the metal ferrule of the brush against the edge of the ruler and draw the brush gently along. Because the bristles of the brush do not actually touch the edge of the ruler, there is no risk of smearing. Allow each individual tile to dry before moving on to the next one, to avoid a major catastrophe by sliding the ruler across the wet paint and smearing it everywhere!

15 Once you have completed all the tiles, take the opportunity to step back and admire the results of all your hard work. Now you can get an overall feel for your painting and make decisions about any final touches. The addition of a few highlights can really lift the painting and bring it to life. Referring back to the original photograph, look closely to see where individual areas catch the light. With pure titanium white and a small round brush. add a highlight to the shadow on the plate.

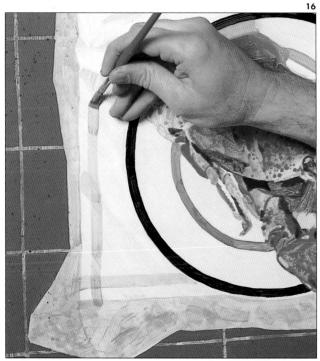

16 To create the illusion of light reflecting off the lobster's shell, mix titanium white with a tiny speck of Turner's yellow and cadmium red and paint a few highlights along the body and on the front claws (you can see this more clearly in the final painting). Now return to the tablecloth and paint in the pattern of blue checks with a dilute wash of cerulean blue and a 1/4 in (7mm) flat brush. When this is dry, add a second wash of blue to those parts of the pattern which are darker in tone, particularly in the folds and creases in the cloth.

17 The completed painting proves that - as in cooking the simplest things are often the best. Refreshingly uncontrived, this still life nevertheless requires a degree of skill, particularly in rendering the texture of the lobster. Do not be put off if your finished painting does not look exactly like this one. The main aim of these projects is to introduce you to the basic techniques, and at the very least this exercise will have shown you what a versatile and expressive medium acrylics are.

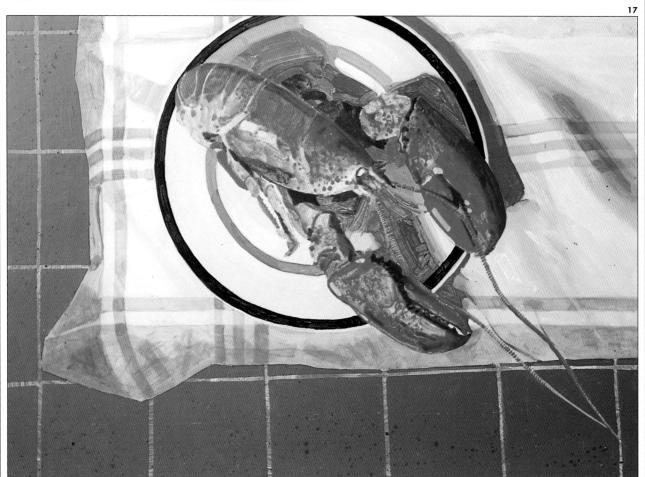

Make-Up

ACRYLICS

For this project we have selected some items of make-up and placed them by the side of a bathroom sink – ordinary objects in an ordinary setting. Although this still life has a slightly 'found' air to it due to its day-to-day content, it is in fact a carefully planned arrangement and will be painted with minute arrangement to detail.

Acrylics are an incredibly versatile medium. They can be used like watercolour or oils, and produce limitless effects peculiar to them alone, so experimenting with a range of techniques and styles can be great fun and very instructive. In the previous exercise we showed you how to work quickly, in a loose and impressionistic style; for this project we show you how to use acrylics in a more considered way. Following the traditional technique of oil painting, you will start by doing a fairly detailed underpainting with thin washes and then build up the painting with thicker paint, carefully modelling the forms of the objects. The amount of intricate detail included might seem daunting, but do not be put off, it is a far simpler job than it first appears.

As with so many of the step-by-step projects in this book, we used some 'artistic licence' in interpreting the subject; although the bathroom tiles were quite shiny, they

were of such a strong colour that reflections of the makeup items tended to disappear. The artist knew that without these reflections, the objects in the finished painting would appear to 'float' above the tiles. so he toned down their colour very slightly and included some soft reflections. The trick is to not feel you have to paint *exactly* what you see, but to add or remove elements as you see fit.

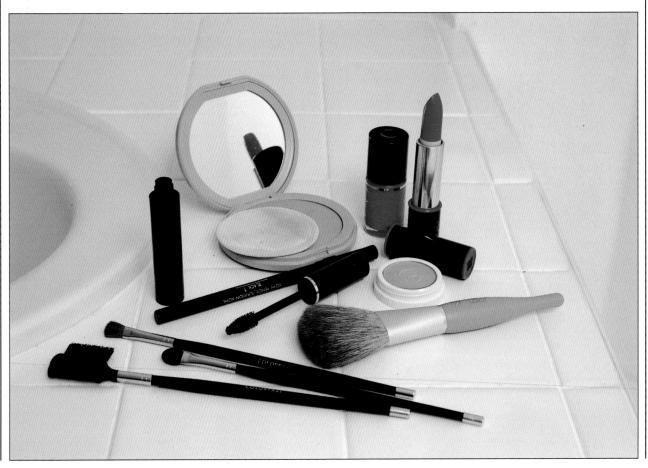

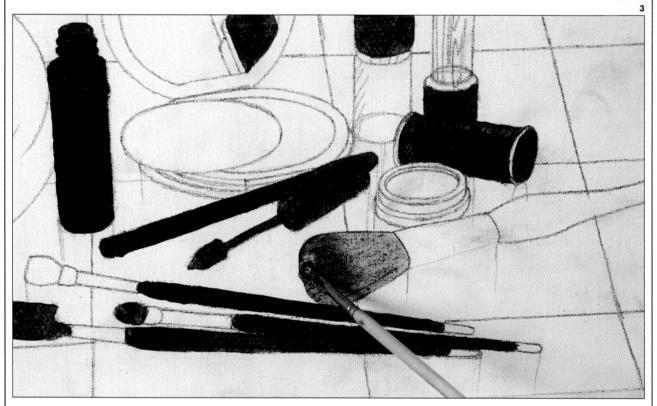

- 1 Start by giving your canvas a couple of coats of liquatex gesso this has good absorbency and is very white and allow it to dry overnight. Since this step-by-step project is to be painted in a very tight style, it is important to make a fairly detailed outline of the subject before you start painting. Use a soft graphite pencil since a hard one would scratch the surface of the
- canvas and use some crosshatching to denote the darkest areas. Do not worry if the lines appear quite heavy – the acrylic paint is opaque enough to cover them.
- 2 The trouble with doing a detailed work such as this in acrylics is that your paints will often dry on the palette before you have a chance to finish with them. So here is a very
- handy hint. Soak a strip of blotting paper in water, lay it down the edge of your palette (it is best if your palette has a rim, to prevent the blotting paper slipping off) and then squeeze out your paints onto it. The water held in the blotting paper will help to keep your paints moist and prevent them drying out.
- 3 You can now start the painting proper. Using Mars black with a small amount of crimson (to add depth of tone), and with a no. 2 flat brush, paint in all the solid black areas. Dilute the mixture with a lot of water to create a very pale tone for the bristles of the brush. Allow this colour to lay heavier towards the end of the bristles to indicate their fullness.

ACRYLICS / MAKE-UP

- Continue by adding a base colour for each of the make-up items, which will act as a guide when you begin the overpainting. In addition, since all of these colours contain an element of black, small areas can be left exposed to represent the very darkest tones later on. Paint the jar of nail varnish with a mix of black and alizarin crimson; the lipstick tube with black and cadmium vellow pale (true cadmium vellow tends to be a bit too orange); the tip of the lipstick with black and cadmium red; and the powder puff and the unpainted parts of the eve brushes with black and cadmium orange. Use this last mixture, but with less water, for the powder in the base of the compact and the small pot of blusher to its right. Next create a medium grey by mixing together black, alizarin crimson and phthalocianine blue (cyan blue) and use this to paint the compact, diluting the mix for the mirror and the metal band round the large brush. Finally, with a heavily diluted mix of black and cadmium yellow pale, paint in the handle of the large brush. Leave these mixes on your palette as you will need them again in step 6.
- Before you can continue you must allow your painting to dry fully. The flurry of activity in the previous step has established all the objects, so the next stage is to apply the base colour for the rest of the picture. The quickest way to do this is to lay a wash over the entire painting - hence the need for it to be totally dry. Create a mix of black and cadmium yellow pale with a small amount of cadmium orange, dilute it with a lot of water and then apply it in a thin, over-all wash from top to

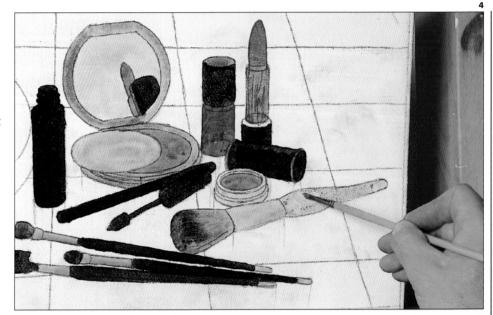

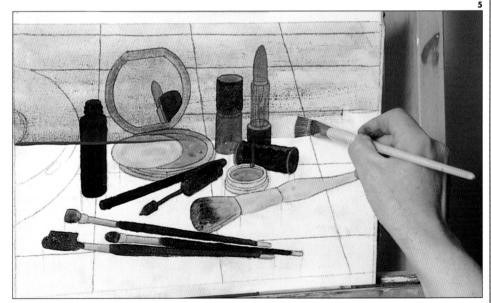

bottom using a reasonably large brush – for example a no. 9. This wash also has the effect of darkening and unifying the colours of the objects already painted.

6 Once the all-over wash has dried you can indicate the soft reflections of the objects on the tiles. Paint each object's reflection with a very dilute wash of the colour used for the objects itself (refer to step 4), using a fairly dry no. 2 brush.

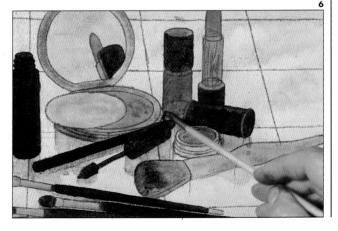

7 It is now the turn of the tiles to receive their base colour. Create a mixture of permanent green deep,

cadmium orange and titanium white and then add a little Mars black. Start at the top of the picture, gradually

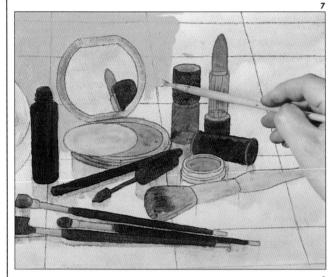

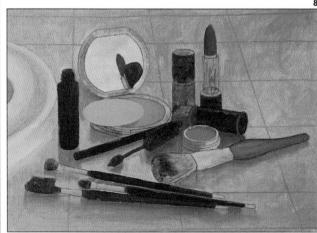

lightening the mix with more orange and white as you move towards the tiles in the foreground. All the initial undercolour has now been laid, so it is important to allow your painting time to dry completely before you continue on to the next step. The beauty of acrylics, of course, is that this takes only ten minutes or so.

Now that the preliminaries are over, you are now into the exciting stage of pulling the whole picture together. Start by reestablishing the reflections in the same tones as before, but this time using thicker, more opaque paint. Using a no. 2 brush, dab the paint on and blend it out into the surrounding tile colour to create a smooth transition of tone. Next, paint the hand basin on the left of the picture with various grey mixes created from alizarin crimson, permanent green deep, Mars black and titanium white, allowing the tones to blend smoothly into each other to mimic the smooth, shiny ceramic surface. A very dark grev mix can also be used to paint the handle of the large brush. Finally, mix together cadmium orange, black and

white, and paint the powder in the base of the compact and the small tub to its right. For the paler tone of the powder puff, add cadmium yellow pale and some more white into your mix. A no. 6 filbert will give you the control needed to paint these smaller, more intricate shapes.

STEP BY STEP

To help really establish your painting, now is a good time to finish painting the tiles. Mix up titanium white with permanent green deep and add a tiny hint of cadmium orange. Most of the background to the picture is made up of these tiles, so make sure that you mix up a sufficient amount to prevent you running out before you complete them. Start at the top of the canvas and paint each tile individually, working out to the edges and leaving the dark undercolour showing through to represent the grouting between the tiles. When you reach the tiles in the foreground, use a dry brush and light, side-to-side strokes so that the tile colour blends smoothly into the reflections previously painted. Once you have finished, allow the whole painting to dry so that you can continue with the make-up items themselves.

ACRYLICS / MAKE-UP

10 To finish your painting it is now a mostly a matter of building up the modelling on the various objects. This requires keen observation of the patterns of light and shade on the objects, and a degree of patience, but this shape will certainly make or break your painting. Start by creating a very pale grey from alizarin crimson, permanent green deep, black and white. Use this mix and a no. 6 filbert to paint in the compact mirror - taking care to work around the reflection of the lipstick in it and the rim and righthand side of the small blusher pot to the right of the compact. Although vou may not realize it, vour original underpainting will be playing its part here, helping you to apply the paint smoothly. Often these very light colours do not come out as opaque when painted straight onto bare canvas - try it for yourself if you have a small scrap of canvas free.

In this photograph you can see how the artist is using a mahlstick. If you do not already own one, get yourself one *now*. Not only do they enable you to work over the top of wet paint, they also steady your painting hand when putting in fine details.

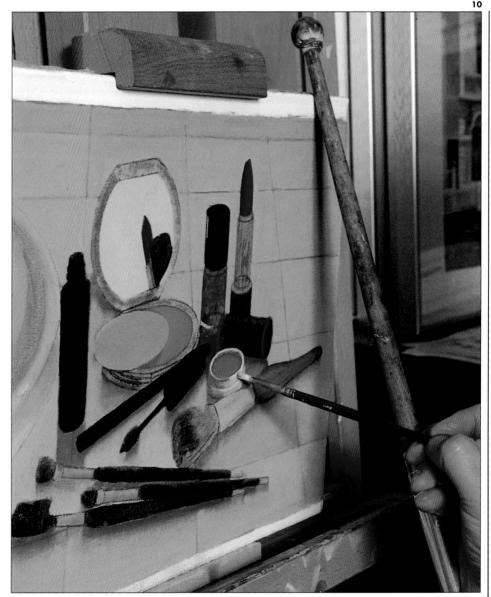

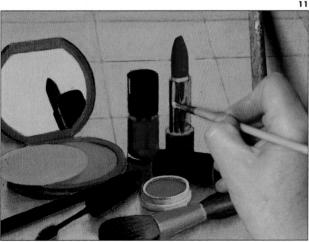

11 Re-paint the jar of nail varnish with alizarin crimson. Using straight Mars black, repaint all the solid black areas. Create a medium grey from alizarin crimson. permanent green deep and a little black, and use this to paint the plastic case of the compact. Use the same mixture to paint the handle of the large brush, lightening the tone with titanium white along the centre and darkening it with black towards to the edges, to model its rounded form. Similar tones

can then also be used for the bristles of the brush, dragging a dry brush through the paint to create the effect of fine hairs. Next, mix together cadmium orange and black with a small amount of your previous grey mix and use this to paint the low-lights on the gold lipstick case and on its reflection in the mirror. Finally, paint the bright highlights on the lipstick case with a light gold colour created from cadmium orange and cadmium yellow pale with hints of black and white.

12 Another grey mix is now required to further define the shape of the hand basin. Again it is made from alizarin crimson, permanent green deep, black and white, but this time with a slight emphasis towards green. Although the ceramic of the basin is white, the shadows within it appear as shades of grey. In addition, the shiny surface picks up and reflects the surrounding

colours – predominantly the green of the tiles, hence the green bias in your grey mix. Vary the tones to define the lip of the basin and allow them to blend into each other to mimic the smooth ceramic surface.

13 All that remains are those small details that will bring the picture to life. For these you will need a writer's brush (so called because they were

originally used for lettering, such as the price tags in shops). This has a square end and very long bristles, giving you greater control when painting fine details.

Create a light pink by adding titanium white to alizarin crimson, and use this to paint the highlights on the jar of nail varnish. Then use a pale peach – cadmium orange and cadmium yellow pale with titanium white – for the edge of the powder puff. Still working in the same area, mix up cadmium red with titanium

white and add the highlight on the end of the lipstick.

STEP BY STEP

14 Switch back to your no. 2 flat brush for a moment, and dry brush some titanium white along the centre of the metal band around the large brush to create a highlight. Then, with the same brush, scumble a lightened version of the colour used for the tiles – titanium white and permanent green deep with a hint of orange – over the foreground tiles to create a sense of depth through the spatial distortion of colour.

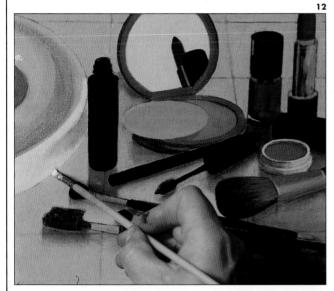

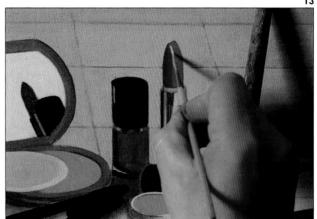

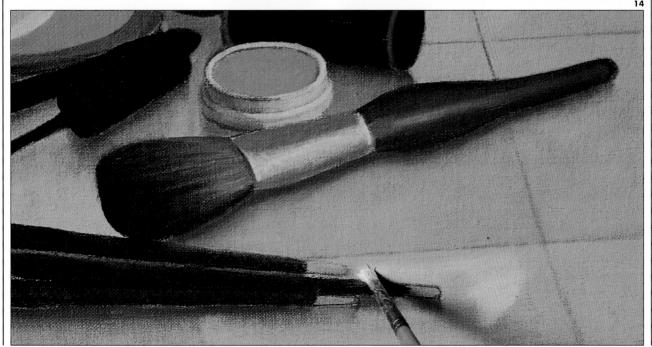

111

ACRYLICS / MAKE-UP

15 You can now switch back to your writer's brush for the remainder of the finishing details. Use pure titanium white to paint the lip of the little pot of blusher, and the highlighted ridge on its front side. Then mix cadmium red with a small amount of black and paint the red bands on the lipstick case and its lid. Next paint in the gold band on the mascara case with a mixture of cadmium orange and cadmium yellow pale with titanium white, increasing the amount of white dramatically for the highlight.

16 Continuing to use your writer's brush, use straight Mars black to repaint the handles of the long brushes and the mascara brush. While this dries, create a medium grey mix from alizarin crimson, permanent green deep, black and white and repaint the bottom lip of the compact to make it a distinctly lighter tone than that of the opened lid. Once all the black areas are dry you can return to them to add the fine highlights. These are created from a mixture of cadmium red and black – a very dark highlight! - and painted by running the ferrel of your brush along the edge of a ruler. Next, paint the brass parts of the long brushes with a mixture of cadmium orange, white and black. Once this has dried, overpaint thin lines of an orange/white mix to represent the highlights using a ruler. Allow this to dry also, and then return to the brass once again, this time with a 50/50 mix of your original brass colour and the highlight colour. Paint this in very thin strips - again using a ruler – along the edges of the highlights to soften them down.

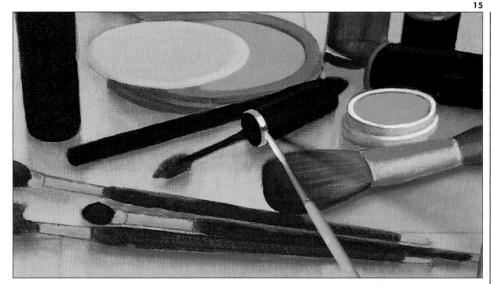

17 You can now finish off the modelling of the compact. Overpaint the inside rim of the upright lid with a mid-grey – alizarin crimson, permanent green deep and white with a suggestion of black – then lighten it with more white for the highlights, and finally darken it down to add the outside lip down the right-hand side. While this is still wet, blend the highlights slightly with a dry brush to soften them.

112

18 The final stage is to paint the highlights along the edges of the tiles and the grouting between them. Add cadmium orange and a small amount of titanium white to the grey mix you used in the previous step, and with the aid of a ruler paint in the grouting. Then lighten this mix right up with white and paint in the highlights using a fairly dry brush with a fine tip and again using the ruler as a guide. You can now 'down brushes' and allow your painting to dry.

In contrast to the previous project, this has been an exercise in fine brush control – and a case where a mahlstick really proves to be worth its weight in gold. Although it is a pleasing still-life composition, the real impact of the finished painting

stems from the sheer amount of lovingly observed detail. But as you have hopefully discovered, intricate details are not necessarily difficult to paint. So long as you kept a steady hand and worked slowly and patiently your finished painting should be very similar to the one shown here – just waiting to impress your family and friends! Beginners often make the mistake of thinking that working in a loose style is guaranteed to lead to success, but in reality a tightly rendered, intricate project such as this is in many ways easier to master. If you decide to paint exactly what you see, in a realistic style, then you immediately get rid of any uncertainties as to what you are going to do. The still life is

laid out in front of you and all you have to do is copy it as closely as possible – what could be easier than that!?

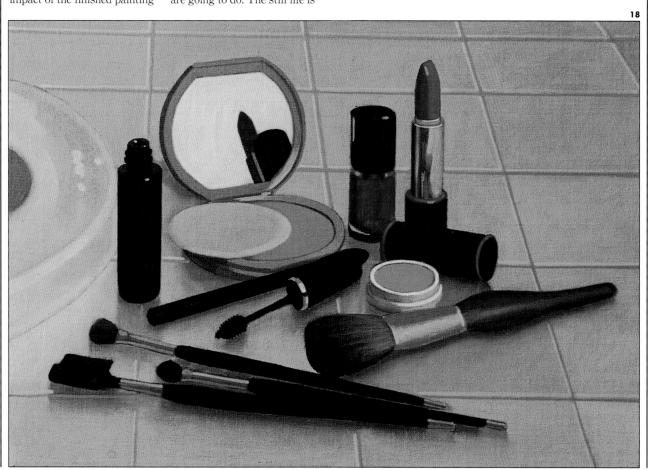

Chapter 7 Oils

Artists today have an almost bewildering array of modern painting and drawing materials to choose from – yet oil paints are still considered the ultimate painting medium. Most of the world's greatest masterpieces were painted in oils, so they have a long and venerable tradition; yet even in today's high-tec world they have lost none of their appeal.

Oil paints were first developed in the 15th century by the Flemish painter Jan van Eyck (c.1390-1441). Until then tempera had been the only painting medium available to artists. Tempera paints were made by mixing powdered colour – often obtained by boiling fruits and then drying them to a powder – with egg yolks and

water. When the paint was brushed on to the painting surface the water evaporated and the egg and pigment dried within minutes to form a hard, matt finish that was liable to cracking.

Van Eyck discovered that by mixing pigments with linseed oil, his paintings dried without cracking. Furthermore, the paint could be applied in transparent layers which enriched the colours and gave them a wonderful luminosity. Since then, generations of artists have discovered the tremendous versatility of oil paints. Whether used thickly for a richly textured effect, or in thin, delicate washes, oils offer a wealth of creative possibilities; even the most experienced artist is never likely to tire of this medium.

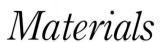

OILS

Paints

Oil paints come in tubes and are made up of pigments suspended in an oil binder such as linseed or safflower oil and occasionally poppy oil which is quicker-drying. There are two grades of oil paint available: artists' and students'. Both are available in a wide range of colours. Although the artists' grade contains more pure pigment and is therefore more expensive, the students' grade is perfectly adequate

and is fine for practising with. The only problem is that not all the colours are obtainable in the students' range, but the two types will mix quite happily in a single painting.

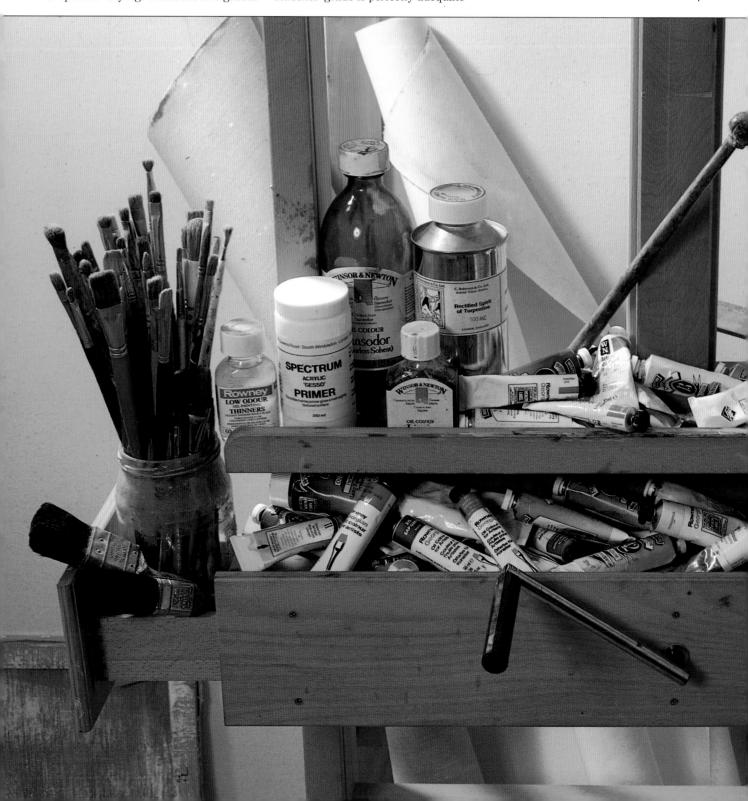

MATERIALS

Painting Mediums

Although oil paint can be used directly from the tube, more often a medium is added which alters the consistency of the paint and makes it more malleable. There are a variety of

mediums available and they all affect the drying rate, flow and texture of the paint in different ways. The most common is a blend of 60% linseed oil to 40% turpentine, but be sure to buy purified or cold-pressed linseed oil

which does not yellow with age. Other mediums include beeswax and turpentine, which dries slowly and gives a matt finish, and gels (synthetic resins) which provide extra body.

Supports

Oil paint can be applied to practically any surface, from canvas – the most commonly used – to wood and hardboard. Stretched canvas provides the perfect support but it is expensive and there are cheaper alternatives. Ready-primed canvas boards are convenient to use, and oil sketching paper, available in pads, is handy for outdoor work. Hardboard, and even cardboard, are inexpensive and provide a good surface but they must be sized on both sides to prevent warping and then properly primed.

Brushes

The best oil painting brushes are made of bleached hog's-hair bristles. They are strong enough for the thick consistency of oil paint and hold the paint well. There are also soft brushes (sable are the best, but synthetic versions are available and are much cheaper) which create smoother, softer strokes and are good for details. They are all available in four basic shapes: filbert, flat, bright and round, the latter being the most versatile. It is always a good idea to buy a variety of sizes, whichever type you choose.

Other equipment

There is an array of accessories to choose from when painting in oils, but the most useful will be a wooden palette. Dippers (small metal cups to hold oil and turpentine) can be clipped to your palette, but jars are just as good. A mahlstick (a long cane with a pad at one end) is useful for steadying your painting arm when adding fine details. Finally, if your budget will allow you, an easel is an investment that you will not regret.

Techniques

OILS

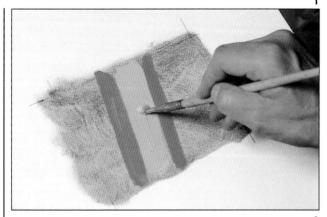

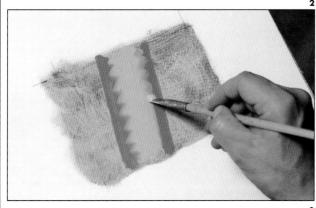

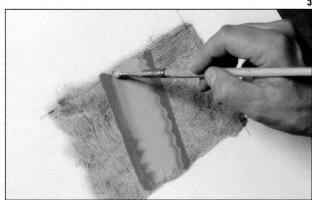

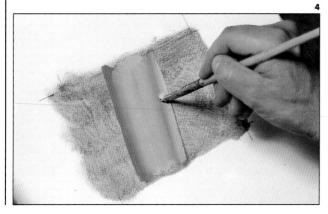

Blending

The following sequence illustrates several blending techniques within the one painting.

Start by laying a base colour and when it has dried paint two parallel lines in one colour, and a lighter tone between them (1). Pull your brush in a zig-zag motion down each side of the centre band to create some spontaneous wet in wet rough-blending of colour (2). The harder you press down on the bristles the more the two colours will merge. This techniques is particularly associated with *alla prima* painting, which is where a work is completed in one sitting.

Many artists, however, prefer a softer blending of colours in their paintings. This is done by gently running your brush up and down where the colours meet (3). They are slowly blended together to create a smooth gradation of colour. The light reflection to one side is painted on fairly dry and dragged up and down through the existing paint (4) to create an instantaneous blending of colour down its edges, while allowing its true colour to remain where it was painted thickest.

Finally, a band of light paint is applied down the centre, and a dry brush is used to drag it into the background form (5) giving a very smooth transition of tone which completes the cylinder.

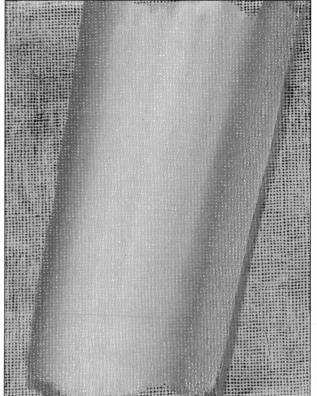

TECHNIQUES

Sgraffito

To create interesting textures and highlights any sharp tool can be used to scratch lines into oil paint while it is still wet. Experiment with different tools – palette and painting knives, the end of a brush handle, even your fingernail – to discover the variety of textures and patterns that can be achieved. You can also scratch through a layer of paint to reveal the underlying colour – as the artist has done here.

Lay a base coat of your chosen colour then, when it has dried, paint over it in another colour (1). The artist used two tones of the second colour, but one tone is sufficient. Whilst the paint is still wet, scratch tiny marks all over it with a palette knife (2). Do not apply too much pressure as you do not want to scratch through the first layer of paint or damage the surface of your support. You can see how the initial layer of paint shows through, creating an interesting, two-toned textural effect.

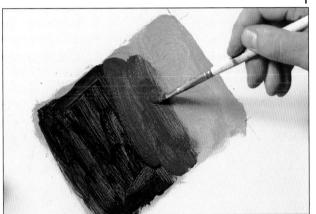

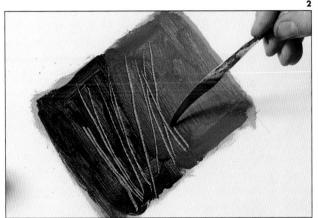

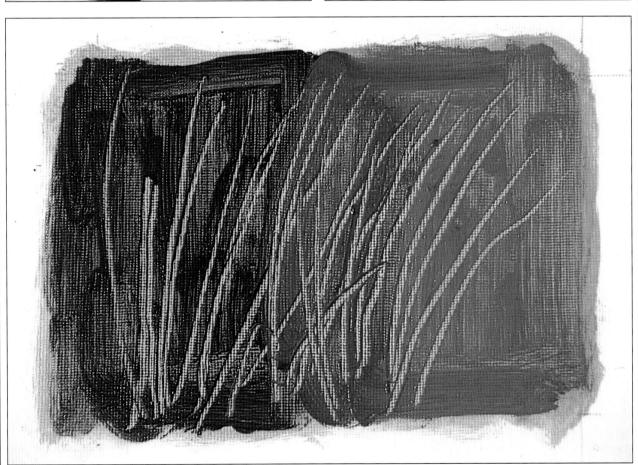

OILS

Spattering

Spattering is when paint is flicked off a brush to create a shower of tiny droplets. It is a technique which can be used in any painting medium and is in fact used for the acrylic project on page 98.

Lay a base colour in a light tone and, when it has dried, load a stiff brush with a darker tone and run your thumb across the bristles. This will cause the paint to fall as a random spray onto your support. The distance you hold the brush from the support will effect the size of the spray, as will your choice of brush and the consistency of the paint.

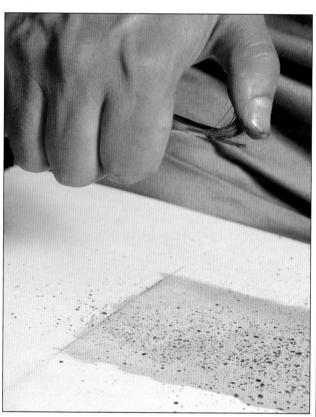

Painting Knife

Because the consistency of oil paint is so wonderfully thick, it is possible to create a whole range of textural effects with the use of a painting knife. Using the paint undiluted, scoop some of your chosen colour onto the end of a small painting knife. Using the flat of the knife, cover the area by drawing the paint across the support with irregular strokes. If you choose to use two colours repeat, using the same technique. The second colour can then be dragged into the first colour to partially mix them.

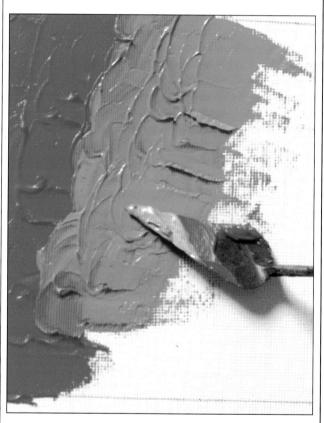

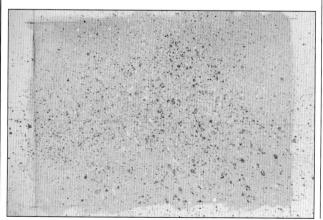

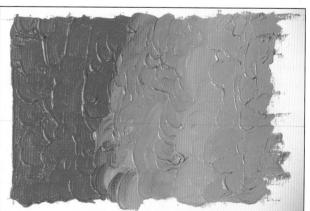

TECHNIQUES

Glazing

Glazing is a technique used for optical mixing. It is a thin layer of transparent colour which is applied over an opaque, dry layer of paint; the glaze combines with the colour below to create a third colour – for example, blue glazed over yellow produces a greenish tint – but the effect is quite different from an equivalent physical mixture of the two colours. This is because the glaze, being transparent, allows light to reflect back off the underlying colour, creating a luminous effect.

To create a sample glaze paint a loose shape of changing colour. When this is dry, use turpentine to dilute a second colour to a transparent consistency and paint a band across the base colours. When the glaze dries, you will see several areas of colour: the three original colours, and an optical mixture where they overlap.

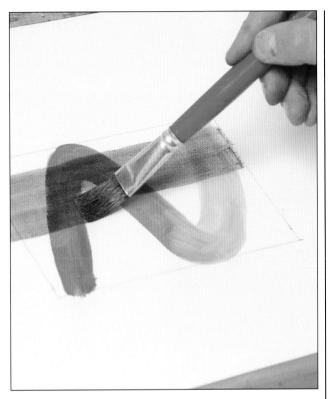

Potted Geraniums

OILS

Plants and flowers are perhaps one of the most traditional still-life subjects, and their wonderful shapes, forms and colours invite many different interpretations. Here we have taken this typical subject, dusted it down and turned it into something new and exciting.

To begin with this would be a classic example of a 'bad' photograph – very strong lighting from the back causing the plants to be in near-silhouette. But the same rules do not necessarily apply to a painting. Here, the strong backlighting is used to give the still life a powerful presence, with strong shadows playing on the table top around it.

Secondly, the potted geraniums selected by the artist are hardly in the traditional mould of 'beautiful'. Past their

summer best, they consist mostly of stems and leaves, with only one flower head remaining. These are sparse plants with a strange, angular, ungainly look, yet their very peculiarity actually adds to the painting, providing a depth of interest in form and content which is sometimes lacking in more conventional flower displays. It is easy to forget that often things which are near-perfect can actually be rather boring to look at.

Finally, the style in which you are going to paint this still life is very loose and impressionistic. This not only takes the finished picture even further away from the traditions associated with such an obvious subject, but, probably more importantly for you if this your first attempt with oils, also makes the project easy to follow.

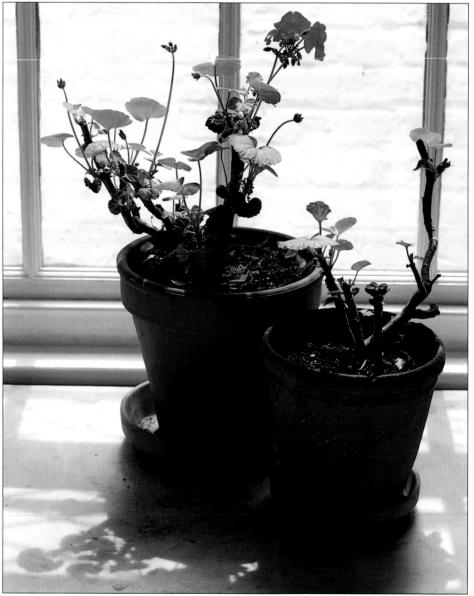

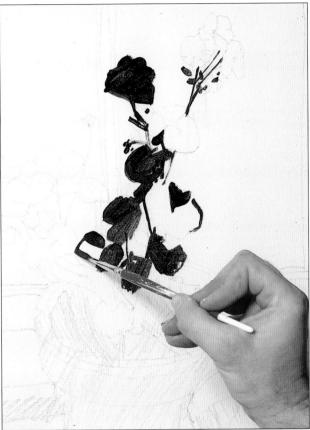

- 1 Start by marking out the main elements in the picture with a soft graphite pencil. Even though this is a fairly simple set-up, these marks will help you to work through the painting in an orderly manner. Since the contrast of light and dark is such an important element in this picture, it is a good idea to indicate the darkest areas with loosely hatched lines.
- 2 Enough with the preliminaries, the painting proper can now begin. On your palette mix viridian, sap green and raw umber to create a very dark green for the foliage in deepest shadow. Paint these using a ¹/₄ in (7mm) flat brush, lightening your mixture slightly with a small amount of titanium white for the mid-tones.

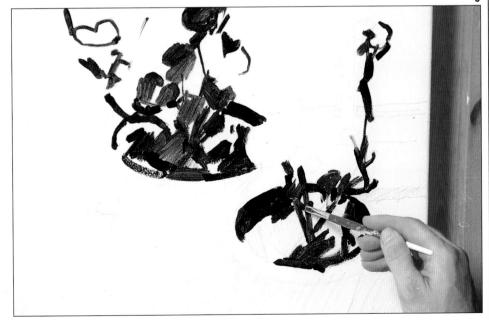

3 Once all the dark leaves and stems have been painted, blend some more raw umber into your green mixture to create a dark brown. Then use this, again with the $^{1}/_{4}$ in (7mm) brush, to paint the soil visible in the tops of the pots.

Again, mix in titanium white for the lighter areas.

OILS / POTTED GERANIUMS

- Now add burnt sienna, cadmium red and yellow ochre into your mixture to create a dark earthenware colour for the pots. For the areas of strong shadow this blend of colours needs to be darkened down with the addition of some cobalt blue which will give a slight blue tinge. If possible, avoid using pure black to darken colours since it tends to have the effect of 'deadening' the other colours present in the mixture. Blue is a more lively shadow colour.
- 5 In this photograph of the artist's palette you can see how all the colours used so far have in fact been extensions of the original dark green mix used in step 2. Not only is this an easy way to work since you are simply adding to your mix as you go but it also lends harmony to the colours in the painting as they contain traces of each other.

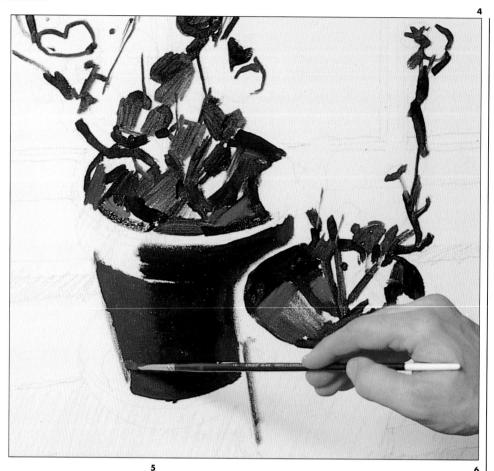

6 Continuing with the pots, and again using your current mixture as a base, add more cadmium red and titanium white to lighten it up. Then paint the next lightest areas — namely the mid tones on the rims of the pots. Lighten the

mix further with more titanium white so that you can paint the highlights and the flat surface of the base for the pot on the left. Leave the remainder of the mix on your palette, but for now it is time for a change of direction.

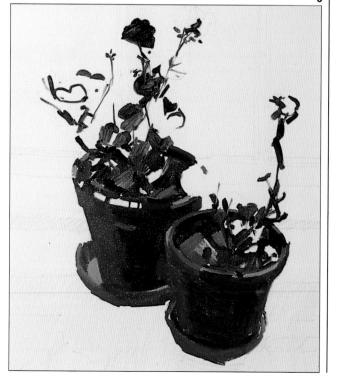

7 Mix together cobalt blue, viridian, raw umber and a tiny bit of titanium white to create a mid-green for the lighter leaf forms. Try not to use the paint too thickly, since you must be careful not to allow the colours to build up too much. This mid-green, although lighter, has a different colour emphasis to the original dark green and

could easily overpower its more subtle predecessor. If you paint these areas with a rather dry brush you will find that this overcomes any potential problems.

8 Progressively lighten the mixture with yellow ochre and titanium white, and work towards the lightest leaves. As

you start to get close to the very lightest leaves add some sap green to your mix to shift the colour emphasis to a pure green rather than the bluegreen of the mid-tones. The suggestion of blue in the darker greens mimics the blue you added into the shadows on the pots earlier and the background colour yet to be

painted. But for the pale greens any element of blue would be a bit too obvious. Instead the warmth of a purer green can be used to emphasize the effect of the strong light/dark contrast in the foliage.

Paint the flower with cadmium red, blending a hint of white into the colour to suggest the lighter petals.

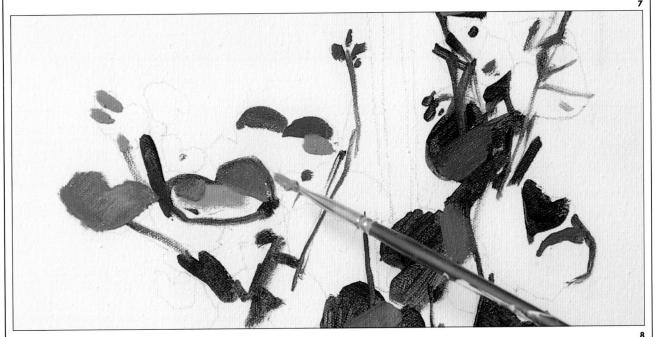

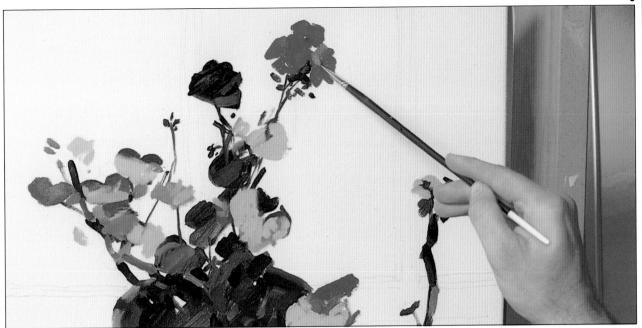

125

OILS / POTTED GERANIUMS

Return to the flower pots, which by now should have dried, and add the pinkish highlights with a mixture of cadmium red, burnt sienna and titanium white. You can now go back to your original mix used in step 2 – use a small amount of turpentine to 'loosen' it up if it has started to dry – and add to it cobalt blue, Payne's grey and sap green. This will create a very dark blue-grey which you can use to repaint the shadows immediately beneath the flower pots.

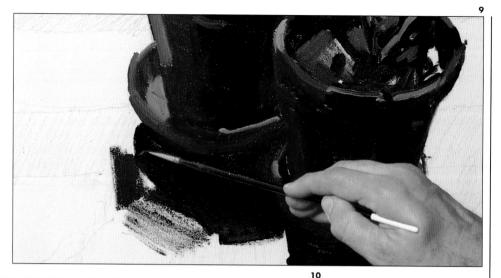

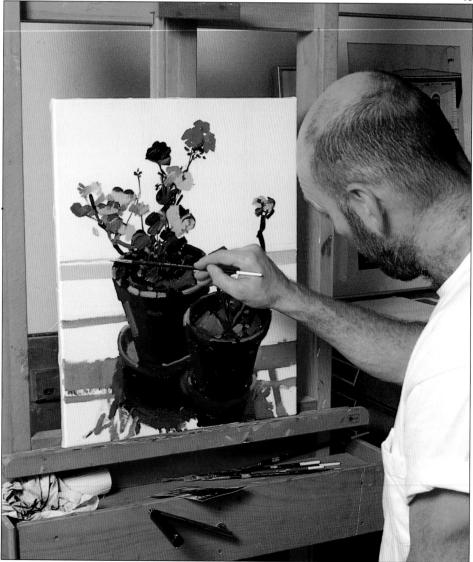

10 Using this same mixture, the remaining shadows on the table top can now be attended to. Lighten the mix with a small amount of yellow ochre and titanium white and start with the dark window frame and the shadows cast by the plants on the table top. Next, add some more yellow ochre and titanium white and paint in the grey highlights on the surface of the soil in the flower pots. Continue with this lightening process and paint in the faint shadows which run across the painting about half way up and paint the window frames themselves.

11 Add yet more yellow ochre and titanium white to your mixture until you end up with a very light grey mixture. You can then use this to paint the remainder of the table top, cutting in around the shapes of the shadows to sharpen and define them.

12 The panes of glass in the window can now be tackled. Mix together cerulean blue and titanium white to create a very pale blue which will not distract the viewer from the focal point of the painting – the flowers in their pots. Use a 1/4 in (7mm) flat to lay in the body of the paint, but switch to an 1/8 in (4mm) flat for the fine, fiddly shapes around the leaves. This 'cutting-in' around the plants will help to establish their edges and so give them a more definite form.

13 You can now add the final, finishing touches to your painting. Re-create your original 'pot' mix of viridian, sap green, raw umber, burnt sienna, cadmium red, cobalt

blue and yellow ochre (not an easy mix to remember!) and return to the flower pots to refine the various tones, lightening your mix as required with titanium white.

OILS / POTTED GERANIUMS

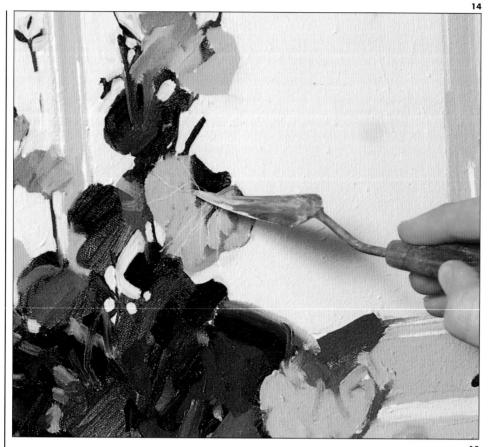

14 Now that all the colours and tones are established you can begin to add textural details. The leaves have tiny veins running across them and the earth in the pots has a rough, crumbly surface. Rather than painstakingly depicting these textures in paint, there is a far simpler option. Simply use the edge of a painting knife - or an old, reasonably blunt kitchen knife - to scratch into the still-wet paint to create the veins and to break up the soil's surface.

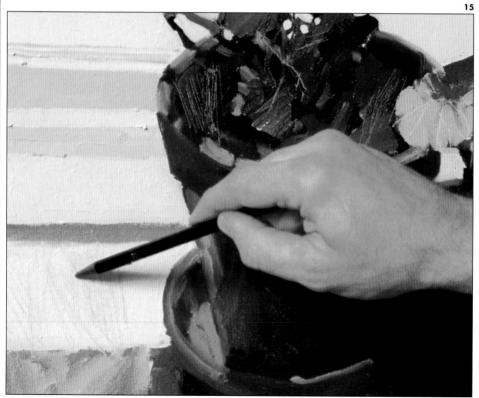

15 Although the table surface looks perfect already, if you check the reference photograph you will realize that is has a slightly mottled marble surface. A great deal of time could be spent in recreating this effect, but again a much easier option exists. Make sure the paint is totally dry, and then add hatched marks with a soft graphite pencil to complete the painting.

16 This loose, impressionistic style of painting is ideal for the beginner – even if you make mistakes nobody is going to notice them – but it is also very enjoyable for the more experienced artist since it allows you to paint what you feel rather than being restricted to painting exactly what you see. Obviously, the nature of a

step-by-step exercise means that some of this spontaneity tends to be lost, but we would encourage you to now create your own still life and paint it in this same style. Only then will you discover the true freedom of interpretation that this direct approach can give to even the most rigidly composed piece.

As can be seen from the reference photograph the colours in the painting have been subtly altered from the original. The greens are stronger and more colourful and the flower now positively 'sings out', demanding the viewer's attention. This is a fine example of the use of complementary colours – in

this case red playing against green – to make the small splash of bright red the most vivid part of the painting. Simple compositional devices like these can often turn a good painting into something truly exceptional.

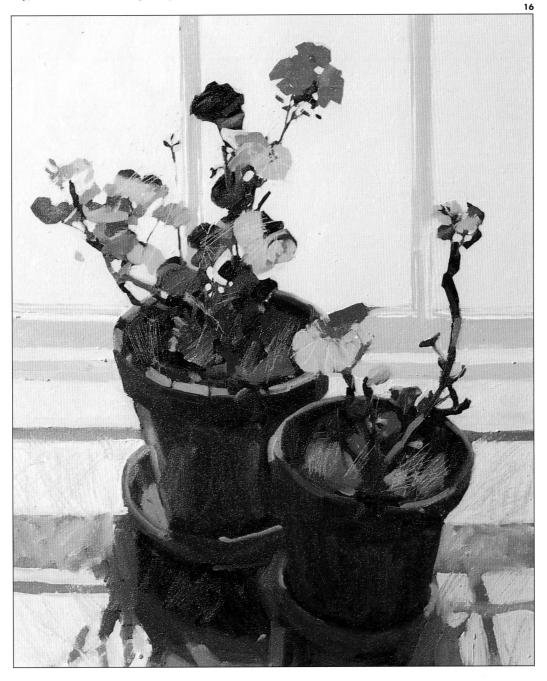

Toaster

OILS

For this final project we thought it would be interesting to apply a traditional style of painting to a contemporary subject – a simple still life of breakfast items, including an electric toaster. The composition is quite basic but interest is provided by the high viewpoint and slightly unfamiliar perspective. The lighting is also very striking, with the early morning sunlight slanting through an unseen window casting strong shadows on the wall and table.

In contrast to the direct approach used in the first oil painting project (see page 122), here the artist has used the time-honoured technique of working up from a monochrome underpainting and building up the colours and tones in a more considered way. Blocking in the main shapes and tones with thin paint helps to establish the composition at the outset, leaving the artist free to concentrate on colour mixing.

Another traditional aspect of this painting is the use of a limited palette of colours, consisting of only cadmium red, cadmium orange, cadmium yellow, ivory black, titanium white and burnt sienna. Far from being restrictive, these few colours can produce a great variety of hues. But because the basic colour range is narrow it creates a harmony that unifies and strengthens the composition.

Although it is preferable to work directly from the subject, in this case the light was changing fast and the shadows were moving, so the artist chose to work from a photograph. However, he soon realized that the group lacked interest, so he included two oranges in his painting – which he studied from life – that were not in the original reference photo. As an artist you need never feel constrained by your subject – you can use as much artistic licence as you like in the cause of creating a better picture.

Since this is the last project, we have included one or two challenging elements to test your skills. The glass of juice offers some interesting difficulties, but the real test comes with the toaster itself. Not only is the perspective quite complex, but the shiny chrome surface is probably something which you have not tried to paint before. Do not be discouraged, when broken down into manageable chunks it reveals all its secrets – and anyway everything else you could ever encounter in a still life will seem easy afterwards!

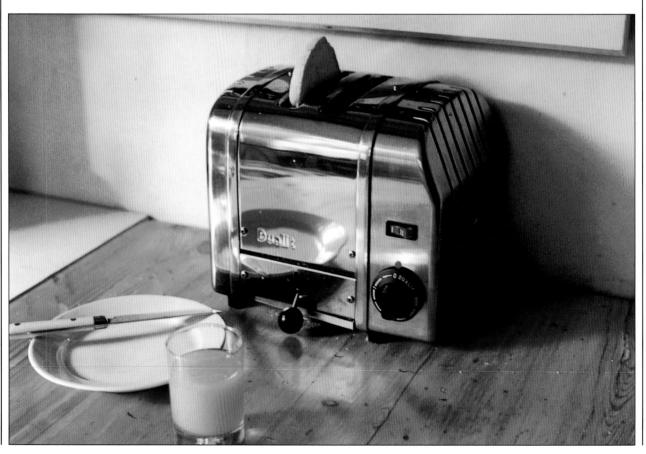

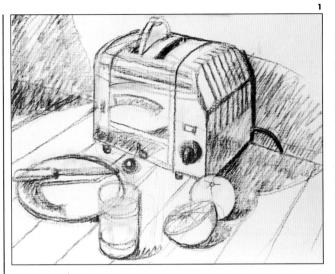

Virtually any support used for oil painting must first be sealed to give you a more suitable surface to paint on. You can buy canvases ready primed, but they are more expensive and, anyway, it only takes a few minutes to do the job yourself; simply apply two coats of gesso primer with a decorator's brush and leave to dry overnight. You are now ready to tackle the project. First, map out the still life with charcoal, using gentle shading to mark areas of dense shadow. Then spray the drawing with

fixative to prevent the charcoal particles merging with the paint and muddying the colours.

- On your palette mix 2 burnt sienna with a small amount of ivory black and dilute it to a wash-like consistency with turpentine. Because the paint is thin, and is not mixed with linseed oil, it will dry fairly quickly. With this mixture you can quickly block in the darkest areas, notably the two large shadows and the top and right-hand end of the toaster, using a no. 8 bristle filbert. Then use straight ivory black to define the slots, vents, feet and knobs on the toaster, and the flex at the back
- 3 Once this is dry, cover the whole picture with a thin wash of burnt sienna, leaving the oranges, the glass, the plate and the main highlights uncovered. Again this is a thin wash, so it should dry quickly and you can start painting the oranges and the glass almost immediately. From this point on you will be using the paint quite thickly. To make the paint more manageable, mix into it a small amount of linseed oil and turpentine in a ratio of 60% oil and 40% turpentine. Orange is the only really pure hue in the painting - the rest is made up of tones and mixes - so it is important to add this as early as possible and build up the rest of the tones around it. Using cadmium orange with a small amount of vellow blended in to lighten it, block in the oranges and the juice in the glass with a no. 6 flat brush.

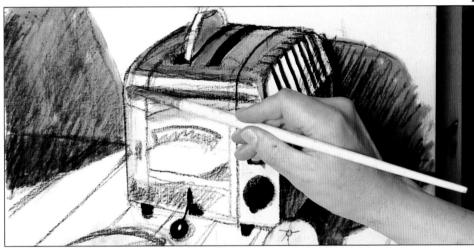

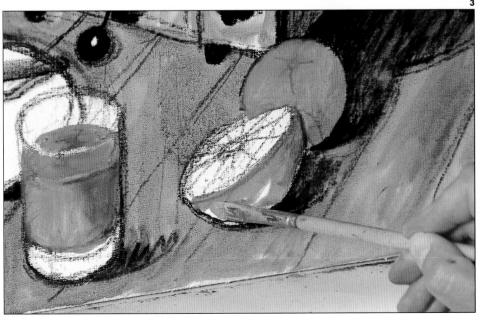

OILS / TOASTER

- Now mix up some titanium white and ivory black, with a small amount of cadmium vellow and cadmium red to add warmth, and switch back to your no. 8 filbert to paint in the background wall. Darken the mix with more black for the shadow areas you have already marked in. Loosely paint the table top with a mixture of cadmium red, cadmium orange, ivorv black and a touch of titanium white, again defining the shadow areas by darkening the mix with additional black. This darker mix can also be used to roughly paint in the gaps between the boards of the table top.
- 5 You can now paint the lower half of the end of the toaster using your no.6 brush with a dark mixture of cadmium yellow, orange and red with a lot of black and white to turn it into the grey tone required for metal. Once you have done this, add more white to your mix and paint the sloping, section of the end of the toaster. Do not worry if you accidentally paint over the lines of the vents since these will be re-defined later.
- Continuing with variations of this mix you can then paint in the front of the toaster, shifting the emphasis to black for the darkest areas and white for the lightest. The greenish grey along the rounded edge at the top is created by adding much more cadmium yellow and ivory black to the mixture. This same combination of colours is also used for the dark shadow on the edge of the plate, with more white added for the lighter shadow in the centre.

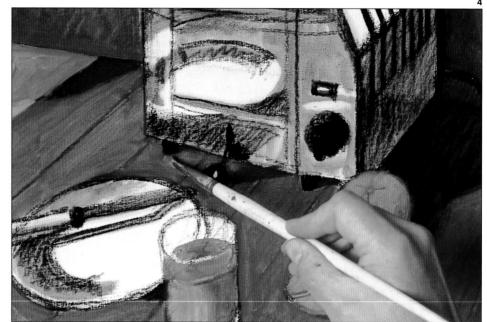

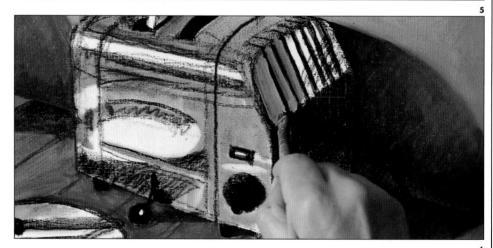

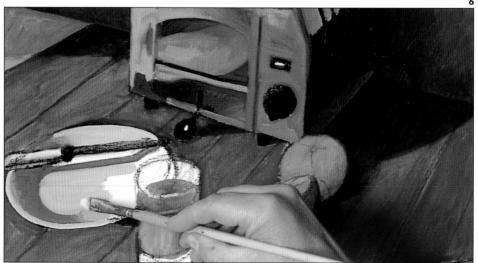

Now begin to work up the rounded forms of the oranges. Start by putting in the midtones with cadmium orange. Then mix in white and vellow for the light areas - not forgetting the pith of the cut orange – and a hint of black for the dark areas, blending each tone into the next to achieve a smooth gradation. Repeat this process for the glass of orange juice. You need only give a suggestion of form at this stage since you will be returning to the oranges later on, but it is important to establish the main areas of light and shadow correctly.

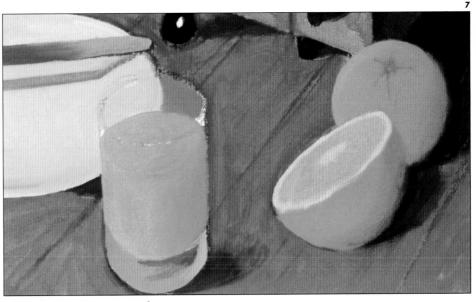

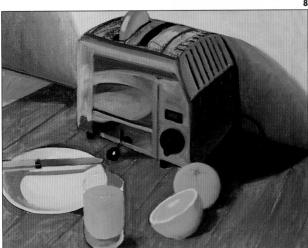

Now paint the slice of toast in the toaster using a mix of cadmium orange and ivory black with a hint of cadmium red, adding more red for the crust and some white for the highlight. Use a variation on this mix for the blade of the knife and the base of the glass. Then start to define the various knobs and switches on the toaster with neat black, and use cadmium red for the on/off switch. You will return to these in the finishing stages of the painting to add the fine details.

The wall in the background now needs to be lightened up slightly by overpainting with a yellow, orange, black and white mixture, dragging a fairly dry brush into the edges of the dark shadows and blending in to create a gentle graduation of tone.

9 An orange, red and black mix can now be used to further define the gaps between the planks on the table top. While the paint is drying, return to the toaster and, using solid black and a no. 4 filbert, redefine the vents on the side of the toaster as well as the rubber feet and the flex. This is the traditional way of working – bringing the whole picture along at once, rather than completing one part and then moving on to the next.

OILS / TOASTER

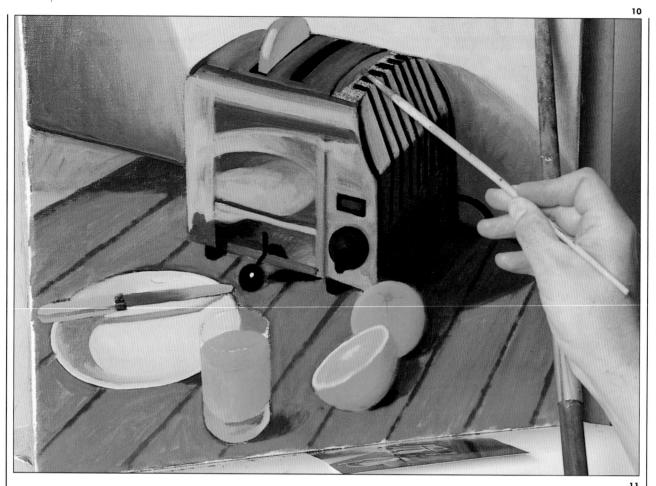

10 You now need to recreate your 'metal' mix - ivory black, titanium white and cadmium vellow, orange and red - but this time with a slight bias towards orange so that it is not as grey as before. Then use this to paint in the top of the toaster. In this photograph you can see the artist making use of a mahlstick (see page 116). Although this is normally used to steady the painting hand when adding fine details, it is also extremely useful in keeping your hand and arm away from the wet paint surface when working on a particular area. We strongly recommend that you buy a mahlstick if you intend to continue working in oils. If you cannot afford to buy one - and they do tend to be quite

expensive for what is basically a stick with a pad on the end – you can easily make one from a garden cane, tipped with padding wrapped in cloth and firmly secured with string.

11 Mix up some cadmium red and cadmium orange with ivory black to create a dark

tone and use this to deepen the cast shadows on the table top and to add a hint of reflected colour on the sides of the oranges. Use this same mix-but with a fairly dry brush to lightly drag the paint in uneven streaks over the wooden planks of the table to indicate the grain marks.

Lighten this mix and dilute it slightly, then apply it over the table, following the general direction of the planks. This wet paint will pick up and slightly merge with the stillwet textural marks you have just laid, so creating the characteristic soft, grainy pattern of wood.

12 You have now passed the half-way mark and it is time to take a well-earned breather. In fact, we would recommend that you leave the painting for at least an hour; you will come back to it with a fresh eye and any mistakes in composition, colour or tone will be immediately apparent. In this particular case, the artist decided to lighten the wall a little further to give more emphasis to the still-life group. He also noticed that the perspective of the line where

the wall and the table meet was wrong – the line to the right of the toaster was too high up. To correct this he simply painted the line in its correct position, re-mixed the colour he used in step 4 for the shadows on the wall, and painted this over the old line.

One other point worth noting here is that the artist has deliberately ignored the reflections of the toaster on the wooden surface, which are evident in the reference photograph, because they would have been very timeconsuming to paint and were not vital to the composition. Never be afraid to identify your limitations or to leave out elements that are unsuitable.

THE YEAR

13 Back to the project proper. Concentrating on the glass of orange juice, lighten the left side with an orange, yellow and white mix. Then darken the colour with a touch of black for the right side. Finally, lighten the mix with lots of white so that you can

add the highlights. A good tip here is to use two brushes, one for adding the highlight colour, and a clean one for blending it in. This allows you to precisely control the amount of colour you put down - especially important where, as in this case, too much colour could easily ruin the result. Note how the various tones in the orange juice are only slightly blended together. This slight separation of colour helps to create the effect of looking at a body of liquid through glass.

13

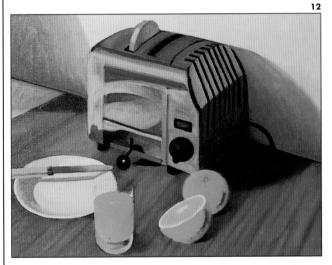

14 Although you added a suggestion of reflected colour to the oranges in step 11, this

was done rather crudely and now needs some working up. Start by using cadmium

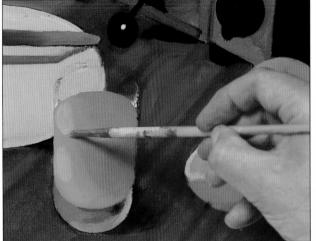

orange to overpaint the shadow areas, allowing it to pick up the dark colour which

should still be slightly wet. These will blend to create a lovely, warm shadow, with traces of the surrounding colours in it. Continue working up the rounded form of the oranges, softly blending the light, medium and dark tones together where they meet. On the underside of the oranges you will notice a lighter area at the edge of the shadow, where the light in the room is reflected up off the shiny wooden surface. As before, the best way to add this subtle highlight is by utilizing two brushes, one to carry the colour (white with a hint of orange), and a dry, clean one for blending.

OILS / TOASTER

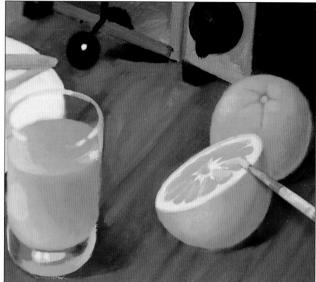

15 Mix up some titanium white and add a hint of your previous orange highlight mix to it. This creates a perfect colour for painting the top side of the knife's handle. Increase the amount of white and add the highlight on the end of the handle, then use the same colour to work up the plate, darkening it for the shadows as necessary. Although you cannot see it in this photograph, the artist is steadying his arm with the mahlstick, and the brush is held well back from the ferrule so that he can see what he is doing. This is especially important if you are righthanded and you are working on the left-hand side of your picture (or vice versa) since your arm will be crossing over your line of sight.

16 Now mix a light grey from black and white and carefully paint the rim and edge of the glass, lightening it slightly for the highlights. This grey colour represents the diffusion of light created at the edge of any piece of glass, and is a good tip to remember. Switching to the oranges, use

pure white to work round the light edge of the cut orange and give a suggestion of the membrane between the segments. You can then mix cadmium yellow and orange with a hint of white and use this to define the segments themselves.

17 The only area in your painting that still needs finishing off is the toaster itself. Mix up black, lots of white and a small amount of orange to create a very pale grey, and use this to block in the lightest areas. The big swirl present on the side of the

toaster is in fact a reflection of the plate distorted in the metallic surface.

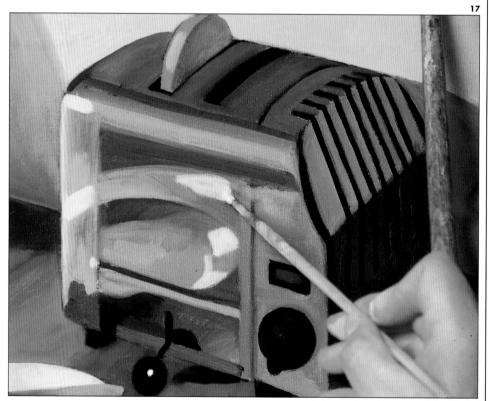

10

18 Alter the mixture by adding more orange to paint the next lightest area. As you can see, this makes the reflection of the plate much more obvious. A shiny metal surface is probably one of the most difficult subjects to paint. The trick is to first establish the base metallic colour - in this case grey for chrome - and then concentrate on the shapes and colours of the reflections present within it. Most importantly, you need to simplify what you see; look for the most important shapes and patches of colour and ignore fiddly details.

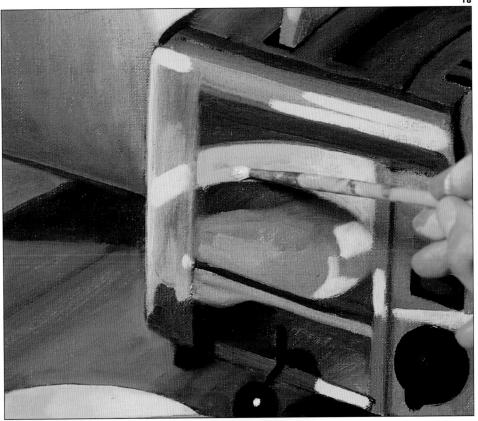

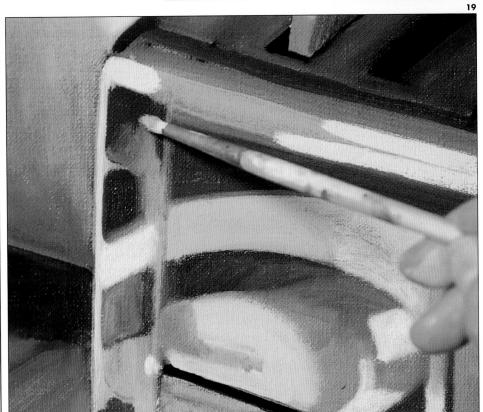

19 Continue adding small patches of colour, treating the reflections as a pattern of abstract shapes and tones. Work towards the darker tones, adjusting your mix as you go and gradually dropping the orange element altogether to arrive at much more harsh greys. Chrome is a highly reflective surface, so there will be strong contrasts of very light and very dark tone in places. Again, avoid fiddly detail – make your brushstrokes smooth and decisive in order to recreate the smooth surface of the metal.

OILS / TOASTER

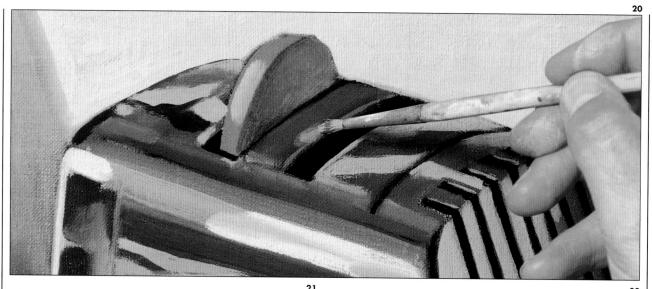

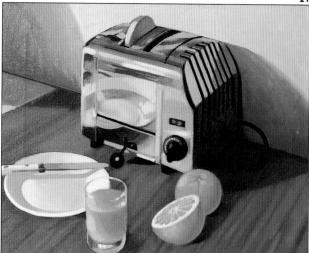

20 Mix a light grey, again with a trace of orange, and use this to overpaint the sloping end of the toaster. Leave the shapes of the cast shadow falling on the toaster unpainted. Variations on this same tone can also be used to add the highlights on the top of the toaster.

21 Your painting is now almost complete. It is simply a matter of adding the finishing touches. Create a medium grey and use this to add the two small rivets on the knife's handle, and to overpaint the blade itself. Lighten the mix

and add a hint of orange, and then use this to re-establish the highlight on the piece of toast. Add small dots of pure white to the knob on the toaster to indicate the scale running round it. Finish off the rocker switch by adding cadmium red to lighten up each end and give it form. You can now leave your painting to dry fully.

22 Once your painting is totally dry it is safe to add the very final element – the thin white and black lines that denote the raised and recessed shapes on the front of the toaster. A steady hand and a

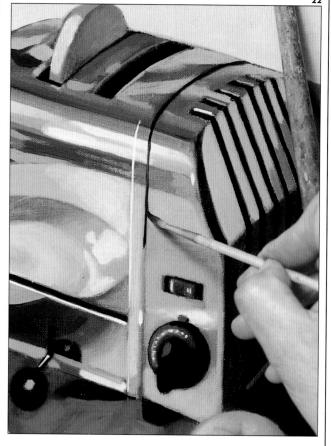

brush with a fine point are essential here. A mahlstick will give you the support required, and a no. 3 sable hair – often referred to as a 'rigger' as it was originally designed to paint the rigging on boats – is

the ideal brush. Even though your painting appears dry, a bristle brush could still disturb the paint underneath, whereas a soft sable brush will glide effortlessly over the paint.

23 There you have it, a finished masterpiece! We hope you enjoyed this project – our artist certainly did. Not only has this illustrated the 'classical' approach to oil painting – a limited palette creating a total harmony of colour, and the extensive use of underpainting – but by marrying this with a very modern subject you have also learned how to tackle shiny metal and glass.

We will not pretend that this was a simple project – you will have your own opinion as to just how difficult it was – but then learning to paint is all about challenges and the battle to overcome them. It is far

better to have attempted this project, but fared badly, than to have just read through it and thought 'perhaps I'll give it a go another time'. Without actually attempting this, you would not have found out what you were capable of. If you have done a perfect painting give yourself a well-deserved pat on the back, but now go on and try something even more challenging. If, on the other hand, you are dissatisfied with your finished work, then examine where you went wrong and practise these areas intensively until you find them easy. By identifying your own faults you are already half-way to correcting them.

Alas this was our final project and so the end of the book. We hope you have enjoyed following the step-by-step projects and learning the basics of drawing and painting still life subjects, and that you will be inspired to continue with this immensely enjoyable and satisfying pastime. Remember, practise makes perfect.

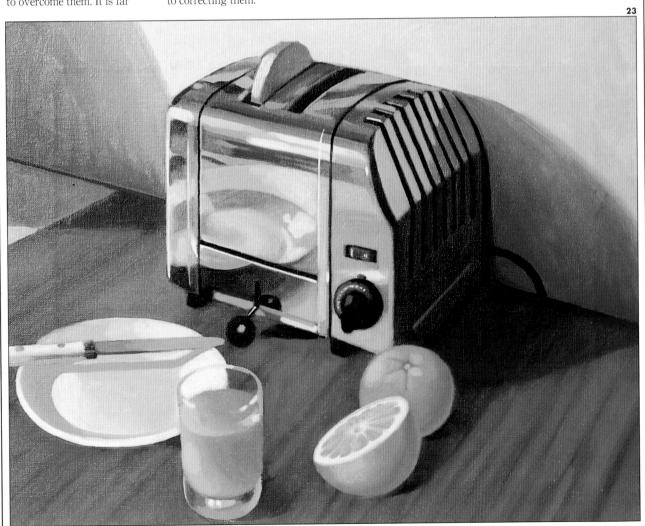

Index

T .		
A	Choosing a medium 21	Н
Acrylics 90-113	Choosing a subject 20-1	
Lobster 98-105	Claesz, Pieter 12, 14	Hatching, charcoal 38
Make-Up 106-13	Claesz, Willem 14	Heda 14
materials 92-3	Colour 22	Heem, Jan Davidsz de 14
techniques 94-7	Coloured papers 57	Highlights, charcoal 33, 40
Aertsen, Pieter 12, 14	Complementary colours 22, 23, 129 Composition 22-7, 78	Hockney, David 90
Artificial light 24	Compressed charcoal 30, 32	Hog hair brush 73, 117
Artificial still life 20	Conté 48-53, 56-61	Horizon line 27
Asymmetry 25	materials 50	
Aubergine Parmigiana 78-83	Satchel, Hat & Coat 56-61	I
	sharpening 52	1
	techniques 52	Ingres paper 31, 37
B	Crosshatching, conté 52, 57	Ink 28-31, 34-5, 42-7
	ink 32	materials31
Backlighting 24, 122	pastels 55	techniques 34-5
Ballpoint pens 31	Cubism 16, 21	Venetian Washing Line 42-7
Barbari, Jacopo de' 12-14		restant tracting Line 12 1
Beijeren, Abraham Van 12, 14		
Beuckelaer, Joachim 12	D	K
Blending, acrylics 97		•
oils 118	Daisies on Kilim 84-9	Kalf, Willem13, 14
pastels 55	Dashes, ink 33	Kneadable Putty Eraser 33
Bosschaert, Ambrosus 14	Design 26	
Braque, Georges 16	Dip pens 31, 32	
Brueghel, Jan 13, 14	Dots, ink 33	L
Brush ruling 104 Brushes acrylic 93 94 5		
Brushes, acrylic 93, 94-5	D.	Laying a flat Wash, Pure Watercolour
Brushes, acrylic 93, 94-5 oil 117	F	74
Brushes, acrylic 93, 94-5 oil 117 watercolour 73		74 Laying a graded wash, Pure
Brushes, acrylic 93, 94-5 oil 117	Felt-tipped pens 31	74 Laying a graded wash, Pure Watercolour 74
Brushes, acrylic 93, 94-5 oil 117 watercolour 73	Felt-tipped pens 31 Fibre-tipped pens 31	74 Laying a graded wash, Pure Watercolour 74 Lichtenstein, Roy 90
Brushes, acrylic 93, 94-5 oil 117 watercolour 73 Burra, Edward 17	Felt-tipped pens 31 Fibre-tipped pens 31 Fine Liners 31, 32, 42-7	74 Laying a graded wash, Pure Watercolour 74 Lichtenstein, Roy 90 Lighting 24
Brushes, acrylic 93, 94-5 oil 117 watercolour 73	Felt-tipped pens 31 Fibre-tipped pens 31 Fine Liners 31, 32, 42-7 Fixative 31, 50, 66	74 Laying a graded wash, Pure Watercolour 74 Lichtenstein, Roy 90 Lighting 24 Linear Strokes, pastels 53
Brushes, acrylic 93, 94-5 oil 117 watercolour 73 Burra, Edward 17	Felt-tipped pens 31 Fibre-tipped pens 31 Fine Liners 31, 32, 42-7 Fixative 31, 50, 66 Flegel, Georg 13, 14	74 Laying a graded wash, Pure Watercolour 74 Lichtenstein, Roy 90 Lighting 24
Brushes, acrylic 93, 94-5 oil 117 watercolour 73 Burra, Edward 17 C Campi, Vincenzo 15 Canson paper 31	Felt-tipped pens 31 Fibre-tipped pens 31 Fine Liners 31, 32, 42-7 Fixative 31, 50, 66	74 Laying a graded wash, Pure Watercolour 74 Lichtenstein, Roy 90 Lighting 24 Linear Strokes, pastels 53
Brushes, acrylic 93, 94-5 oil 117 watercolour 73 Burra, Edward 17 C Campi, Vincenzo 15 Canson paper 31 Canvases see Supports	Felt-tipped pens 31 Fibre-tipped pens 31 Fine Liners 31, 32, 42-7 Fixative 31, 50, 66 Flegel, Georg 13, 14 Flotsam and Jetsam 62-9	74 Laying a graded wash, Pure Watercolour 74 Lichtenstein, Roy 90 Lighting 24 Linear Strokes, pastels 53 Lobster 98-105
Brushes, acrylic 93, 94-5 oil 117 watercolour 73 Burra, Edward 17 C Campi, Vincenzo 15 Canson paper 31 Canvases <i>see</i> Supports Caravaggio, Michelangelo Merisi da	Felt-tipped pens 31 Fibre-tipped pens 31 Fine Liners 31, 32, 42-7 Fixative 31, 50, 66 Flegel, Georg 13, 14 Flotsam and Jetsam 62-9 Found still life 20, 42	74 Laying a graded wash, Pure Watercolour 74 Lichtenstein, Roy 90 Lighting 24 Linear Strokes, pastels 53
Brushes, acrylic 93, 94-5 oil 117 watercolour 73 Burra, Edward 17 C Campi, Vincenzo 15 Canson paper 31 Canvases <i>see</i> Supports Caravaggio, Michelangelo Merisi da 13, 14, 15	Felt-tipped pens 31 Fibre-tipped pens 31 Fine Liners 31, 32, 42-7 Fixative 31, 50, 66 Flegel, Georg 13, 14 Flotsam and Jetsam 62-9 Found still life 20, 42 Fountain pens 31	74 Laying a graded wash, Pure Watercolour 74 Lichtenstein, Roy 90 Lighting 24 Linear Strokes, pastels 53 Lobster 98-105
Brushes, acrylic 93, 94-5 oil 117 watercolour 73 Burra, Edward 17 C Campi, Vincenzo 15 Canson paper 31 Canvases see Supports Caravaggio, Michelangelo Merisi da 13, 14, 15 Centre of vision 27	Felt-tipped pens 31 Fibre-tipped pens 31 Fine Liners 31, 32, 42-7 Fixative 31, 50, 66 Flegel, Georg 13, 14 Flotsam and Jetsam 62-9 Found still life 20, 42 Fountain pens 31 French Impressionists 16, 48	74 Laying a graded wash, Pure Watercolour 74 Lichtenstein, Roy 90 Lighting 24 Linear Strokes, pastels 53 Lobster 98-105
Brushes, acrylic 93, 94-5 oil 117 watercolour 73 Burra, Edward 17 C Campi, Vincenzo 15 Canson paper 31 Canvases see Supports Caravaggio, Michelangelo Merisi da 13, 14, 15 Centre of vision 27 Cézanne, Paul 14, 16	Felt-tipped pens 31 Fibre-tipped pens 31 Fine Liners 31, 32, 42-7 Fixative 31, 50, 66 Flegel, Georg 13, 14 Flotsam and Jetsam 62-9 Found still life 20, 42 Fountain pens 31	74 Laying a graded wash, Pure Watercolour 74 Lichtenstein, Roy 90 Lighting 24 Linear Strokes, pastels 53 Lobster 98-105 M Mahlstick 110, 117, 134
Brushes, acrylic 93, 94-5 oil 117 watercolour 73 Burra, Edward 17 C Campi, Vincenzo 15 Canson paper 31 Canvases see Supports Caravaggio, Michelangelo Merisi da 13, 14, 15 Centre of vision 27 Cézanne, Paul 14, 16 Charcoal 28-33, 36-41	Felt-tipped pens 31 Fibre-tipped pens 31 Fine Liners 31, 32, 42-7 Fixative 31, 50, 66 Flegel, Georg 13, 14 Flotsam and Jetsam 62-9 Found still life 20, 42 Fountain pens 31 French Impressionists 16, 48	74 Laying a graded wash, Pure Watercolour 74 Lichtenstein, Roy 90 Lighting 24 Linear Strokes, pastels 53 Lobster 98-105 M Mahlstick 110, 117, 134 Make-Up 106-13
Brushes, acrylic 93, 94-5 oil 117 watercolour 73 Burra, Edward 17 C Campi, Vincenzo 15 Canson paper 31 Canvases see Supports Caravaggio, Michelangelo Merisi da 13, 14, 15 Centre of vision 27 Cézanne, Paul 14, 16 Charcoal 28-33, 36-41 compressed 32	Felt-tipped pens 31 Fibre-tipped pens 31 Fine Liners 31, 32, 42-7 Fixative 31, 50, 66 Flegel, Georg 13, 14 Flotsam and Jetsam 62-9 Found still life 20, 42 Fountain pens 31 French Impressionists 16, 48 G Glazing, oils 121	74 Laying a graded wash, Pure Watercolour 74 Lichtenstein, Roy 90 Lighting 24 Linear Strokes, pastels 53 Lobster 98-105 M Mahlstick 110, 117, 134 Make-Up 106-13 Manet, Edouard 15, 16 Materials, acrylics 92-3 charcoal 30-1
Brushes, acrylic 93, 94-5 oil 117 watercolour 73 Burra, Edward 17 C Campi, Vincenzo 15 Canson paper 31 Canvases see Supports Caravaggio, Michelangelo Merisi da 13, 14, 15 Centre of vision 27 Cézanne, Paul 14, 16 Charcoal 28-33, 36-41 compressed 32 hatching 38	Felt-tipped pens 31 Fibre-tipped pens 31 Fine Liners 31, 32, 42-7 Fixative 31, 50, 66 Flegel, Georg 13, 14 Flotsam and Jetsam 62-9 Found still life 20, 42 Fountain pens 31 French Impressionists 16, 48 G Glazing, oils 121 Gogh, Vincent van 15, 16	74 Laying a graded wash, Pure Watercolour 74 Lichtenstein, Roy 90 Lighting 24 Linear Strokes, pastels 53 Lobster 98-105 M Mahlstick 110, 117, 134 Make-Up 106-13 Manet, Edouard 15, 16 Materials, acrylics 92-3 charcoal 30-1 conté 50
Brushes, acrylic 93, 94-5 oil 117 watercolour 73 Burra, Edward 17 C Campi, Vincenzo 15 Canson paper 31 Canvases see Supports Caravaggio, Michelangelo Merisi da 13, 14, 15 Centre of vision 27 Cézanne, Paul 14, 16 Charcoal 28-33, 36-41 compressed 32 hatching 38 materials 30-1	Felt-tipped pens 31 Fibre-tipped pens 31 Fine Liners 31, 32, 42-7 Fixative 31, 50, 66 Flegel, Georg 13, 14 Flotsam and Jetsam 62-9 Found still life 20, 42 Fountain pens 31 French Impressionists 16, 48 G Glazing, oils 121 Gogh, Vincent van 15, 16 Golden Section 26, 27	74 Laying a graded wash, Pure Watercolour 74 Lichtenstein, Roy 90 Lighting 24 Linear Strokes, pastels 53 Lobster 98-105 M Mahlstick 110, 117, 134 Make-Up 106-13 Manet, Edouard 15, 16 Materials, acrylics 92-3 charcoal 30-1 conté 50 gouache 72-3
Brushes, acrylic 93, 94-5 oil 117 watercolour 73 Burra, Edward 17 C Campi, Vincenzo 15 Canson paper 31 Canvases see Supports Caravaggio, Michelangelo Merisi da 13, 14, 15 Centre of vision 27 Cézanne, Paul 14, 16 Charcoal 28-33, 36-41 compressed 32 hatching 38 materials 30-1 Old Telephone 36-41	Felt-tipped pens 31 Fibre-tipped pens 31 Fine Liners 31, 32, 42-7 Fixative 31, 50, 66 Flegel, Georg 13, 14 Flotsam and Jetsam 62-9 Found still life 20, 42 Fountain pens 31 French Impressionists 16, 48 G Glazing, oils 121 Gogh, Vincent van 15, 16 Golden Section 26, 27 Gouache 70-3, 76-7, 84-9	T4 Laying a graded wash, Pure Watercolour 74 Lichtenstein, Roy 90 Lighting 24 Linear Strokes, pastels 53 Lobster 98-105 M Mahlstick 110, 117, 134 Make-Up 106-13 Manet, Edouard 15, 16 Materials, acrylics 92-3 charcoal 30-1 conté 50 gouache 72-3 ink 30-1
Brushes, acrylic 93, 94-5 oil 117 watercolour 73 Burra, Edward 17 C Campi, Vincenzo 15 Canson paper 31 Canvases see Supports Caravaggio, Michelangelo Merisi da 13, 14, 15 Centre of vision 27 Cézanne, Paul 14, 16 Charcoal 28-33, 36-41 compressed 32 hatching 38 materials 30-1 Old Telephone 36-41 techniques 32-3	Felt-tipped pens 31 Fibre-tipped pens 31 Fine Liners 31, 32, 42-7 Fixative 31, 50, 66 Flegel, Georg 13, 14 Flotsam and Jetsam 62-9 Found still life 20, 42 Fountain pens 31 French Impressionists 16, 48 G Glazing, oils 121 Gogh, Vincent van 15, 16 Golden Section 26, 27 Gouache 70-3, 76-7, 84-9 Daisies on Kilim 84-9	T4 Laying a graded wash, Pure Watercolour 74 Lichtenstein, Roy 90 Lighting 24 Linear Strokes, pastels 53 Lobster 98-105 M Mahlstick 110, 117, 134 Make-Up 106-13 Manet, Edouard 15, 16 Materials, acrylics 92-3 charcoal 30-1 conté 50 gouache 72-3 ink 30-1 oils 116-7
Brushes, acrylic 93, 94-5 oil 117 watercolour 73 Burra, Edward 17 C C Campi, Vincenzo 15 Canson paper 31 Canvases see Supports Caravaggio, Michelangelo Merisi da 13, 14, 15 Centre of vision 27 Cézanne, Paul 14, 16 Charcoal 28-33, 36-41 compressed 32 hatching 38 materials 30-1 Old Telephone 36-41 techniques 32-3 willow 32	Felt-tipped pens 31 Fibre-tipped pens 31 Fine Liners 31, 32, 42-7 Fixative 31, 50, 66 Flegel, Georg 13, 14 Flotsam and Jetsam 62-9 Found still life 20, 42 Fountain pens 31 French Impressionists 16, 48 G Glazing, oils 121 Gogh, Vincent van 15, 16 Golden Section 26, 27 Gouache 70-3, 76-7, 84-9 Daisies on Kilim 84-9 materials 72-3	T4 Laying a graded wash, Pure Watercolour 74 Lichtenstein, Roy 90 Lighting 24 Linear Strokes, pastels 53 Lobster 98-105 M Mahlstick 110, 117, 134 Make-Up 106-13 Manet, Edouard 15, 16 Materials, acrylics 92-3 charcoal 30-1 conté 50 gouache 72-3 ink 30-1 oils 116-7 pastels 50
Brushes, acrylic 93, 94-5 oil 117 watercolour 73 Burra, Edward 17 C Campi, Vincenzo 15 Canson paper 31 Canvases see Supports Caravaggio, Michelangelo Merisi da 13, 14, 15 Centre of vision 27 Cézanne, Paul 14, 16 Charcoal 28-33, 36-41 compressed 32 hatching 38 materials 30-1 Old Telephone 36-41 techniques 32-3	Felt-tipped pens 31 Fibre-tipped pens 31 Fine Liners 31, 32, 42-7 Fixative 31, 50, 66 Flegel, Georg 13, 14 Flotsam and Jetsam 62-9 Found still life 20, 42 Fountain pens 31 French Impressionists 16, 48 G Glazing, oils 121 Gogh, Vincent van 15, 16 Golden Section 26, 27 Gouache 70-3, 76-7, 84-9 Daisies on Kilim 84-9	T4 Laying a graded wash, Pure Watercolour 74 Lichtenstein, Roy 90 Lighting 24 Linear Strokes, pastels 53 Lobster 98-105 M Mahlstick 110, 117, 134 Make-Up 106-13 Manet, Edouard 15, 16 Materials, acrylics 92-3 charcoal 30-1 conté 50 gouache 72-3 ink 30-1 oils 116-7

N	R	ink 34-5 oils 118-21
Natural light 24	Renaissance 26	pastels 53-5
Natural still life 20, 62	Renoir, Pierre Auguste 14, 16, 21	pure watercolour 74-5
		Tempera 114
_		Textures 25, 78
O	S	Themes 21 Thick over thin, acrylics 96
Ohlieus nevensative 97	Sable brush 73	Thin over thick, acrylics 96
Oblique perspective 27 Oil pastels 50	Sánchez-Cotán, Juan de 14-5	Thumbnail sketch 63
Oils 114-39	Satchel, Hat & Coat 56-61	Toaster 130-9
materials 116-7	Scribbling, ink 33	Tone, Charcoal32
Potted Geraniums 122-9	pastels 54	Torchon 50, 55
techniques 118-21	Scumbling, pastels 54	Toulouse-Lautrec 48
Toaster 130-9	Seligman, Lincoln 16	
Old Telephone 36-41	Sgraffito, oils 119	
_	Sketch book 28	\mathbf{V}
	Soft blending, charcoal 33	
P	Spattering, acrylics 101	Valerio, James 17
9	oils 120	Van Eyeck, Jan 114
Painting knife 120	Step-by-step projects, acrylics 98-113	Vanishing point 27
Painting mediums, acrylic 92	Aubergine Parmigiana 78-83	Velázquez, Diego Rodriguez de Silva y 14
oils 117	charcoal 36-41 conté 56-61	Venetian Washing Line 42-7
Palettes, acrylics 93	Daisies on Kilim 84-9	Vertical Lines, ink 33
oils 117 watercolour 73	Flotsam and Jetsam 62-9	Viewpoint 26-7
Papers, Canson 31	gouache 84-9	Viewpoint 20 i
coloured 57	ink 42-7	
Ingres 31, 37	Lobster 98-105	\mathbf{W}
watercolour 73	Make-Up 106-13	••
Parallel perspective 27	oils 122-39	Warhol, Andy 16, 90
Pastels 48-51, 62-9	Old Telephone 36-41	Water into ink 33
Flotsam and Jetsam 62-9	pastels 62-9	Wesselmann, Tom 17
materials 50	Potted Geraniums 122-9	Wet into wet, gouache 76
techniques 53-5	Pure Watercolour 78-83	pure watercolour 75
Pens 31	Satchel, Hat & Coat 56-61	Wet on dry, gouache 77 pure watercolour 75
Perspective 27	Toaster 130-9 Venetian Washing Line 42-7	White Chalk 33, 39, 40
Picasso, Pablo 16	Stilleven 14	Willow charcoal 32
Pissarro, Camille 16 Plato 22	Stub holder 37	Writer's Brush 111
Pointillism 52	Supports, acrylics 93	,,,,,,,,,,,,,,,,,,,,,,,,,,,,,,,,,,,,,,,
Pop Art 90	oils 117	
Potted Geraniums 122-9	Symmetry 25	Z
Pure Watercolour 70-5, 78-83	,	Z
Aubergine Parmigiana 78-83		Zurbarán, Francisco 14
materials 72-3	T	
techniques 74-5		
	Technical pens 31	
	Techniques, acrylics 94-7	
$ \mathbf{Q} $	charcoal 32-3	
_	conté 52	

gouache 76-7

Quills 31

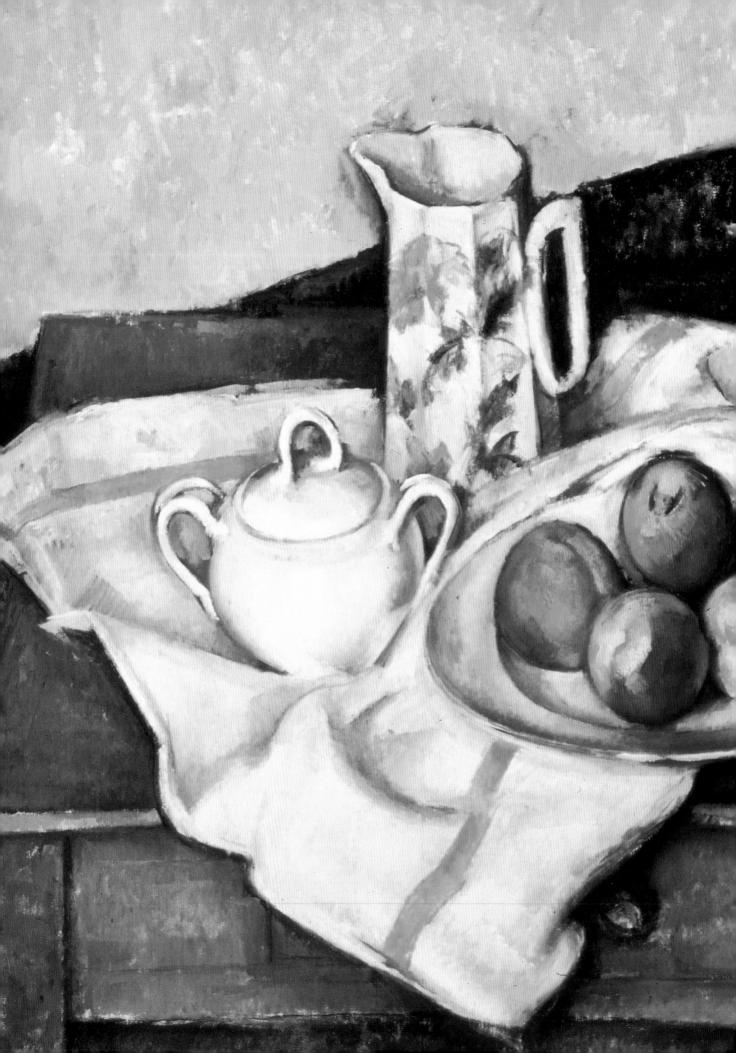